IMAGES
of America

GRANT COUNTY

ON THE COVER: Pictured here is the entire student body of the Neppel School District in 1926–1927. At the time, J. G. Sargent was the county superintendent, and Mr. Grover was the superintendent of the high school. Other teachers were Thelma Wait, Chloe Dungan, Helen Temperly, and Mrs. Archie Tucker. (Courtesy of Grant County Historical Museum.)

IMAGES
of America

GRANT COUNTY

Elizabeth Gibson

ARCADIA
PUBLISHING

Published by Arcadia Publishing
Charleston SC, Chicago IL, Portsmouth NH, San Francisco CA

Printed in the United States of America

Library of Congress Catalog Card Number: 2007921323

For all general information contact Arcadia Publishing at:
Telephone 843-853-2070
Fax 843-853-0044
E-mail sales@arcadiapublishing.com
For customer service and orders:
Toll-Free 1-888-313-2665

Visit us on the Internet at www.arcadiapublishing.com

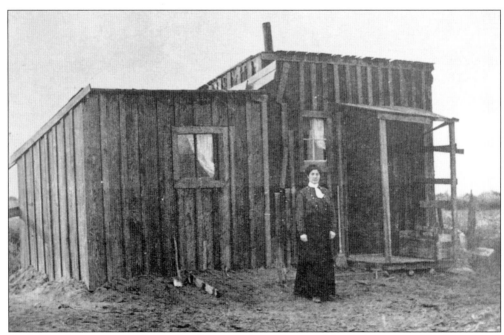

Enola Henderson poses in front of her home in the early part of the 20th century. This homestead was about a mile southeast of Quincy. Enola came to the area with her brother Otto and sister Adela and worked in the Quincy hotels and cooked for harvest threshing crews. She later trained as a nurse. Her brother Otto was a photographer and left behind many historical photographs of the Quincy area. (Courtesy of Quincy Valley Historical Society.)

CONTENTS

ACKNOWLEDGMENTS

Grant County was the last county to be formed in Washington, in 1909. Over 100 years later, very little has been written to chronicle the history of the county. Hopefully this book can inspire interest in capturing history before it is lost. Several official sources helped me tell the story of Grant County: Grant County Historical Museum, Moses Lake Museum and Art Center, Quincy Valley Historical Society, Washington State Potato Commission, Ephrata Airport Interpretive Center, Schiffner Military Museum, Grant County Public Utility District, Port of Moses Lake, Mattawa Family History Group, Desert Aire History Group, Big Bend Community College, the *South County Sun*, and the Columbia River Exhibition of History, Science and Technology. Other sources helped me pinpoint dates, places, and names of the people who shaped the county, including CCRS.org, *Grant County Journal, Columbia Basin Herald, Quincy Post-Register,* and *Tri-City Herald.*

There are a number of individuals who generously contributed photographs for this project, including Bob Holloway and Mick Qualls from Ephrata; Margaret Schiffner and Harold Hochstatter from Moses Lake; Kathy Kiefer, Gordon Tift, Duane Nycz, Linda Bonneville, the Klasen family, the Waltho family, and the Agranoff family from Soap Lake; and John Ball, Bob Kibler, Velma Best, JoAnn Pearson, Bud Clerf, LouAnn Davis, Shirley Stewart, and Raymond Grove from south Grant County. Others, who do not live in the county but have connections to it, also contributed their photographs, including Rick Bowles, Ross Davidson, Virginia Sheldon, Glen and Valerie Thiesfeld, and Richard Wiehl.

Finally, I would like to acknowledge the U.S. Bureau of Reclamation, whose perseverance from the 1930s through the 1950s brought Grand Coulee Dam and irrigation to Grant County. Though the Grant County Historical Museum, Moses Lake Museum and Art Center, and the Quincy Valley Historical Society contributed some photographs that appear in this book, the photographs exist because the bureau chronicled their progress throughout the era. Specific pictures taken by the bureau appear on pages 43 (bottom), 56 (top), 87 (top), 84 (top), 89 (bottom), 90, 91, 92, 94, 95, 96, 97, 98, 101 (top), 107, and 119.

INTRODUCTION

Located in the geographical center of Washington state, Grant County was the last county to be created. Prior to its formation in 1909 from Douglas County, it was mainly a place that travelers crossed to get somewhere else. Those travelers occasionally encountered the local natives, mainly the Wanapum and Sinkiuse Indians, who counted on the salmon harvest and the annual buffalo hunt to the east. They also dug camas roots, hunted the local deer and elk, and gambled and raced horses.

David Thompson of the Northwest Fur Company was probably the first white man to visit this part of the state. He traded with the friendly tribes in the Priest Rapids area. The Hudson's Bay Company fur traders also explored the area. Charles Wilkes led the U.S. Exploring Expedition through the area in 1841. Ferries took miners across the Columbia River to the White Bluffs area, where they could continue their journey to the gold mines in British Columbia. The ferries also served soldiers, who were establishing forts in the northern counties. Some grazed cattle along the trails to sell to miners and the military.

It was not until the 1880s that people stopped passing through and put down roots. By that time, most of the clashes between Native Americans and white men had been resolved. The Sinkiuse, led by Chief Moses, agreed to go to the Colville Reservation. The Wanapums continued to live at a remote location near Beverly. Tom and James McManamon were among the first ranchers; they settled on Crab Creek in the southern part of the county. Pioneers established a small town at McEntee's Crossing (later Coulee City), the only natural crossing place of the giant Grand Coulee formation. The Egbert brothers started a ranch, and Frank Beazley established an orchard south of Ephrata.

Settlement remained sparse until the railroads came through. The Northern Pacific Railroad built a line across the county in 1892, setting up the future towns of Quincy, Hartline, Warden, and Winchester. The Great Northern completed a line that passed through the future town of Ephrata in 1893, and the town grew as a shipping center for cattle and horses. The Great Northern also established a section crew and depot at Trinidad and a roundhouse and maintenance shops at Wilson Creek.

Now that railroads crisscrossed the county, getting crops and livestock to market was assured. Wheat was the first big crop and cattle the livestock of choice. Ephrata was platted in 1901, and two years later, it had 200 people and about two dozen businesses. Quincy Siding was also established that year. The Quincy Land and Improvement Company promoted the area, and soon there was a post office, hotel, butcher shop, bank, newspaper, and many other businesses. Settlers established Neppel on the banks of Moses Lake about 1907 and began marketing fish. People started to notice the medicinal powers of Soap Lake and built a small town around it to take advantage of the soothing waters and muds.

A third railroad, the Chicago, Minneapolis, and St. Paul, was built during the first few years of the 20th century. People clustered around Ephrata, Quincy, and Neppel. Ephrata was chosen as the county seat in 1909, and a courthouse was erected shortly afterward. Large orchards

were planted at Neppel, Stratford, Grant Orchards, Quincy, and Trinidad. Electrical power and telephone service arrived over the next two decades. State highway 2, completed in 1910, ran through Coulee City, helping to put that town on the map. Soap Lake residents erected a number of sanitariums to cater to those desiring to cure various ailments by drinking, swimming, or bathing in its waters.

Drought, followed by the Great Depression, caused many farmers to give up and leave the area. In 1933, Pres. Franklin D. Roosevelt created the Works Progress Administration to help get people back to work. One of the biggest projects under this program was the completion of the Grand Coulee Dam. The Grand Coulee Dam was the anchor of the Columbia Basin Irrigation Project, a concept promoted as early as 1918. Several small towns formed on both sides of the Columbia River to support the workers building the dam.

Upon its completion in 1942, the dam was initially used for power production rather than irrigation. By then, the United States had entered World War II and needed hydroelectricity to manufacture aluminum for airplanes and to power the Hanford Nuclear Project in northern Benton County, where production of plutonium for an atomic bomb was being manufactured. Irrigation was put on hold. During the same time, the military built air bases at Ephrata and Moses Lake, renamed from Neppel in 1938. The military also built a bombing range near Royal City. The military presence led to a surge in population in both direct and indirect employment that supported the bases.

It would still be a few years before reliable irrigation would make the desert bloom. And work continued on the irrigation network that would be needed to bring water to the county. James O'Sullivan and I. N. McGrath worked diligently to form the irrigation districts necessary to receive water from the Columbia Basin Irrigation Project. Construction on O'Sullivan Dam, started in 1947, was completed in 1949. The Potholes Reservoir formed behind the dam to collect runoff irrigation water to rechannel it for use farther south.

In 1950, pumps began lifting Columbia River water into the Banks Lake Reservoir near Grand Coulee Dam. From the reservoir, an intricate series of canals and siphons channeled water in two directions south of the lake. The town of George, Washington, arrived at the same time the irrigation canals did. The streets were named after different varieties of cherries such as Bing and Royal Anne. The Winchester Waterway created a network of canals that had a side benefit of providing wildlife and bird-watching areas. Sugar beet production grew so successful that U&I Sugar built a factory to process sugar beets into refined sugar in 1953. Potato harvesting became extraordinarily successful during the 1950s. The one town that grew alarmed at the excess water was Soap Lake; runoff and seepage from the Columbia Basin Irrigation Project was diluting Soap Lake. City fathers took steps to protect their biggest commodity from further "pollution." Ultimately over 500,000 acres would be irrigated, much of it in Grant County.

In the 1960s, the bases were shut down, and residents were worried about employment. Some of the lost jobs were temporarily replaced as workers were needed to build the Wanapum and Priest Rapids Dams in the western part of the county. The town of Mattawa was formed to house the workers, and some stayed to farm after the dam projects were complete. Big Bend Community College opened in 1962, and after 1966, it expanded into some of the old air base buildings. The main airfield at Moses Lake became Grant County International Airport, and Boeing Aircraft Company and Japan Airlines began using the airport for training pilots.

In modern times, agriculture is still king in Grant County. This region claims to have the highest potato yield per acre, particularly in the Warden area. Growing grapes for wine has also become popular in the Wahluke Slope area and the Quincy Valley. Tourism plays a big part of the economy, luring outdoorsmen, geology buffs, and wine lovers to the area. Soap Lake has seen a resurgence in visitors taking advantage of the mineral waters of its famous lake. George boasts the state's most popular outdoor amphitheater at the Gorge at George. The county has also seen some diversification with a number of high-tech, manufacturing, and retail businesses that call Grant County their home.

One

COUNTY BEGINNINGS

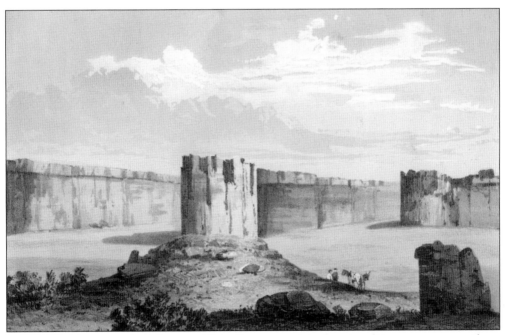

In 1853, Washington territorial governor Isaac Stevens organized an expedition to survey a northern route for a railroad. American artist John Mix Stanley accompanied him, and he preserved many scenes of nature and of Native Americans. The route took the expedition to Fort Colville and down the Columbia River to Vancouver. Stanley sketched this view of the Grand Coulee during one of numerous side trips taken on the journey. (Courtesy of Elizabeth Gibson.)

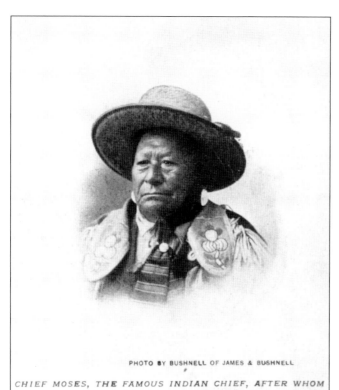

CHIEF MOSES, THE FAMOUS INDIAN CHIEF, AFTER WHOM THE VALLEY WAS NAMED

Sulktalthscosum, known as Chief Moses (1829?–1899), was the leader of the Sinkiuse tribe of north central Washington. His territory ranged from Douglas County west and south to the White Bluffs area on the Columbia River, an area that encompasses parts of Grant County. He was respected for his diplomacy and intelligence. He tried to negotiate a separate reservation for his own people, but ultimately ended up on the Colville Reservation. (Courtesy of Moses Lake Museum and Art Center.)

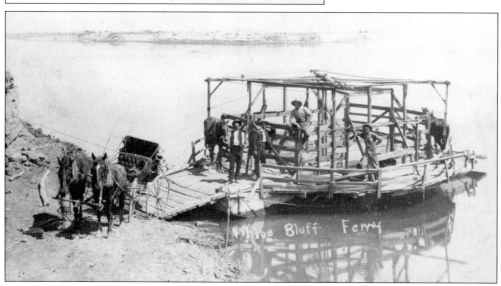

The southern part of Grant County was bordered by the Columbia River, and anybody needing to travel farther north had to cross the river. Various ferries operated over the years, taking prospectors, soldiers, and settlers across the river, through Grant County, and to places farther north. This paddle-wheel ferry began service about 1901, powered by two horses, Pete and Ginger. Matt Wiehl is the young man on the far right. (Courtesy of Richard Wiehl.)

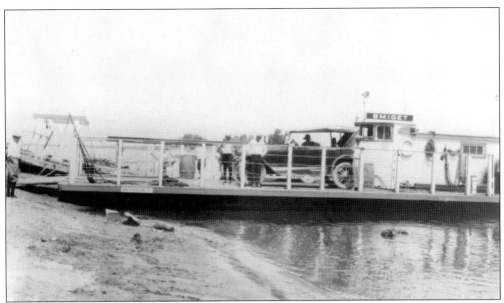

John Preston initially operated the Smiget ferry; Matt Wiehl bought the boat, originally named *Bertha*, in 1918. Wiehl operated the ferry until the state took over the landing site about 1938. The ferry's engine went to a Yakima machine shop, and an upriver resident bought the paddle wheel. This was the last private ferry to operate in this part of the county. (Courtesy of Richard Wiehl.)

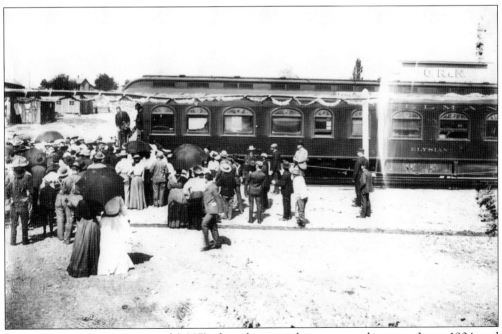

Quincy was not yet incorporated (1907) when this special train stopped in town. It was 1904, and Theodore Roosevelt was touring the United States to win votes for his second term. He spent the night at Trinidad, on the western edge of the county, in order to arrive in Quincy at a designated time. A large crowd was on hand to greet him. (Courtesy of Mick Qualls.)

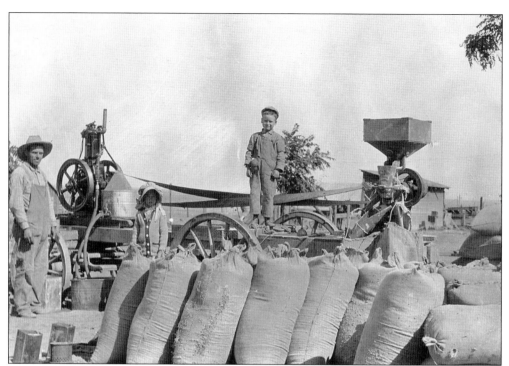

Mike Erdman sowed grain at his farm near Low Gap in 1908. He came to this area from Salt Lake City in 1903. His daughter Donna and son are pictured here. These sacks of grain have been packaged for stock feed. (Courtesy of Grant County Historical Museum.)

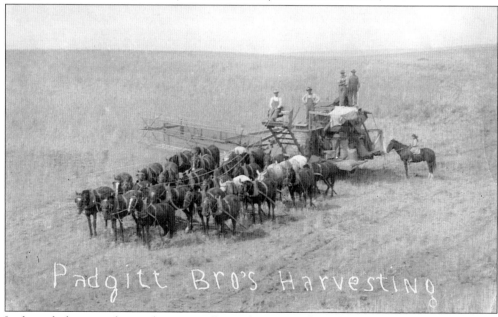

In the early days, it took many horses to pull a combine. Here the Padgitt brothers, Harry and Walter, pictured on the back of the combine, lead a team of at least two dozen horses as they sow wheat. In addition to wheat farming, they raised hogs. Sister Laura Padgitt sits on the lone horse. They also had a half brother named D. C. Adams. (Courtesy of Grant County Historical Museum.)

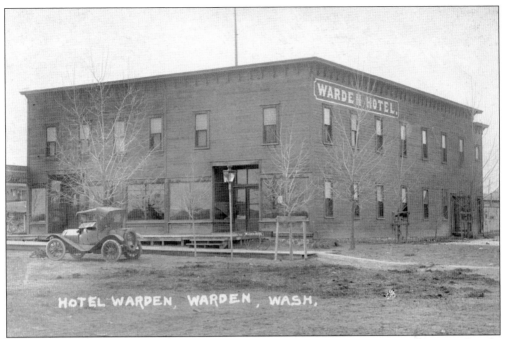

Stockmen brought cattle and horses to this area in the 1870s. With coming of two railroads, though, the Northern Pacific in 1903 and the Chicago, Milwaukee, and St. Paul in 1909, the new town of Warden was formed. Named for one of the railroad's prominent stockholders, the town had about 173 residents by 1910. This is the hotel in Warden, about 1910. (Courtesy of Elizabeth Gibson.)

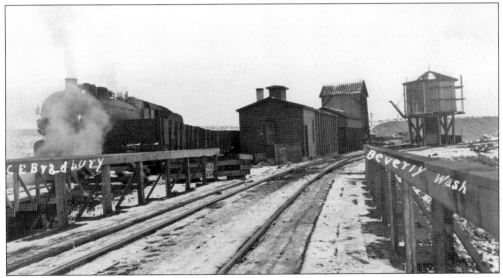

The Chicago, Milwaukee, and St. Paul Railroad built its line through Grant County in 1909. The bridge crossed the Columbia River a mile and a half upstream from the mouth of Crab Creek. The town of Beverly grew up around the railroad. It was named by railroad vice president H. R. Williams after Beverly, Massachusetts. Steam-powered engines were used until about 1925, when the railroad electrified the entire line. The railroad abandoned this line in 1980. (Courtesy of JoAnn Pearson.)

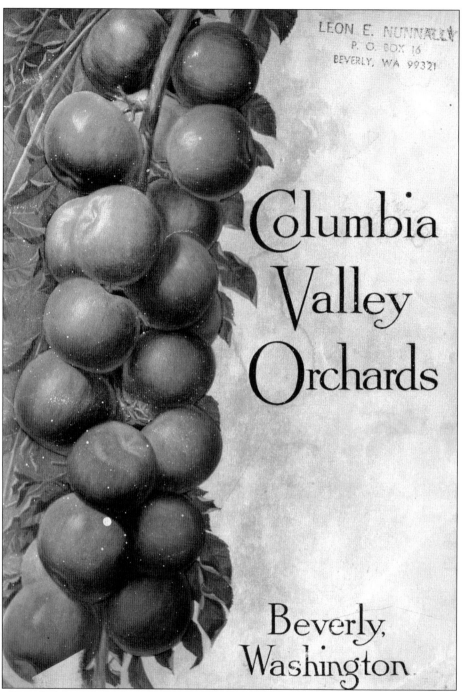

LEON E. NUNNALLY
P. O. BOX 16
BEVERLY, WA 99321

Columbia Valley Orchards

Beverly, Washington.

The Beverly Improvement Company formed around 1910 to promote the Beverly area and encourage settlement. The company published this booklet in 1911, complete with full-color pictures illustrating everything from the planned orchards to modern irrigation and the first businesses. Harry B. Averill wrote the text to accompany the pictures. The company was convinced that its perfect growing conditions, combined with the town's central location for transporting crops, would make the area boom. (Courtesy of JoAnn Pearson.)

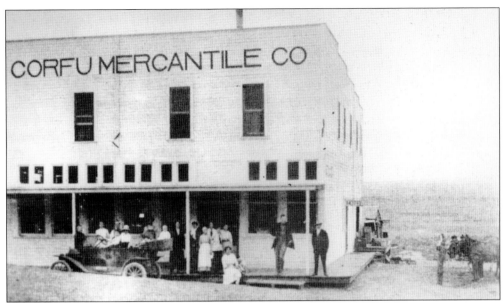

Corfu was a railroad shipping point on the Chicago, Milwaukee, and St. Paul Railroad along the Saddle Mountains in south Grant County. Pictured is the Corfu Mercantile Company, which Frank Martin built about 1911. The building contained a general store, post office, and hotel. The foundation of this building is all that remains today. (Courtesy of *South County Sun*.)

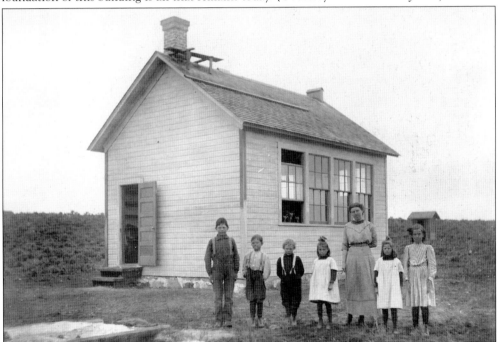

This photograph of Crab Creek School is dated about 1912. This early school was located at what is now called Rocky Ford Crossing, five miles east of Ephrata. Rocky Ford Creek flows into the north end of Moses Lake. From left to right are Per Kriet, Bill Kriet, Frank Mortomor, Fern Haas, teacher Mrs. Roimegan, Ada Haas, and Hazel Kriet. (Courtesy of Grant County Historical Museum.)

Pictured is George Schiffner, whose parents, George and Annabel Schiffner, came to Washington from Russia about 1890. He married Mary Dills, daughter of pioneer Rev. J. H. Dills of Wilson Creek. The Dills family owned over 300 acres and raised many crops. The Great Northern Railroad was built through the area in 1892, putting Wilson Creek on the map. The couple's son George Schiffner was a longtime resident of Moses Lake. (Courtesy of Margaret Schiffner.)

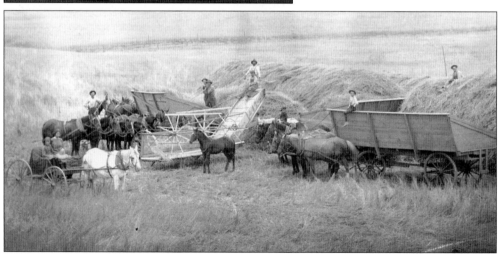

Carl C. Larsen raised hay at a farm west of Coulee City in the 1910s. Pictured are Mabel and Martha Larsen (in buggy), Jack Larsen (on header), Ben Larsen and his friend Harry White, Carl C. Larsen, Henry Hjalmer, Dick Larsen (on horse), Walt Larsen (on header box), and Louis Larsen (on haystack). (Courtesy of Grant County Historical Museum.)

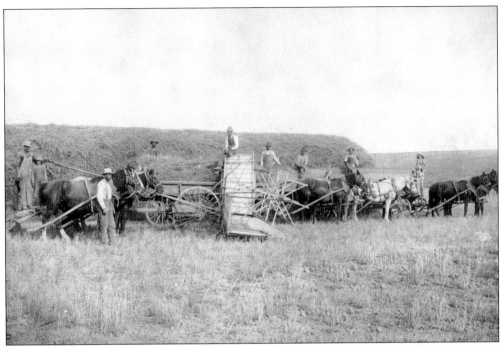

J. Harvey White harvested wheat in the Pinto Ridge area in 1914. He came to Creston, Washington, from Virginia in 1903, and moved to Pinto Ridge in 1906. In the front of the header box are John H. White, Violet E. White (Greenlee), and Gertrude H. White (Keska). With the header puncher is Marlin L. White. (Courtesy of Grant County Historical Museum.)

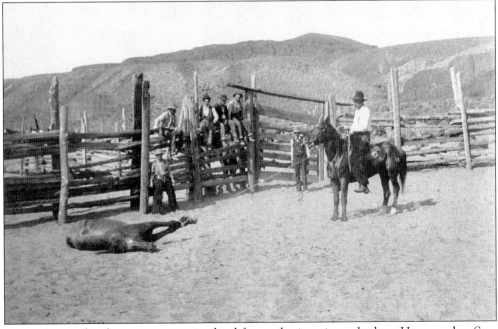

Grant County has been prime grazing land for cattle since its early days. Here rancher Sam Hutcheson ropes a calf. Watching are Grant Smith, John Brookhour, Owen Minoton, Sam Brumbaugh, Merrel Terry, and Zack Borden. (Courtesy of Grant County Historical Museum.)

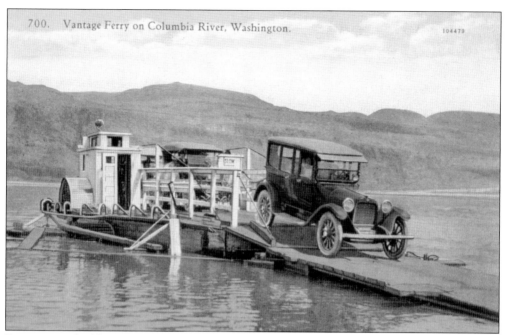

Ferry service had been available between Grant County and Kittitas County near modern-day Vantage since 1909, when Clarence D. Heywood operated a cable ferry. A few years later, the two counties took over operation of the ferry and replaced the cable ferry with a side-wheeler. This boat was retired in 1918 and replaced by the *Kitty-Grant*, which operated until a highway bridge was finally built in 1927. (Courtesy of Glen and Valerie Thiesfeld.)

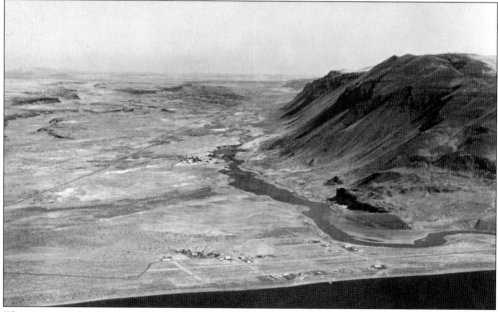

This is an early photograph of Schwanna showing its proximity to Crab Creek and Saddle Mountain. Saddle Mountain rises approximately 1,600 feet above the surrounding plain. There are geologic faults along the ridge; an earthquake was recorded here in November 1918. (Courtesy of JoAnn Pearson.)

18

Pictured around 1928 is the Corfu School, a two-room schoolhouse that was made of brick. The teacher was Florence Watson, whose parents, Charles and Louisa Watson, moved to the area in 1908. Florence Watson attended Ellensburg Normal School and taught school from 1923 to 1930. She later married Forest Chadbourne, and the couple lived in the area. In the 1960s, their property was sold to the Royal Bluffs Hunting Club. (Courtesy of LouAnn Davis.)

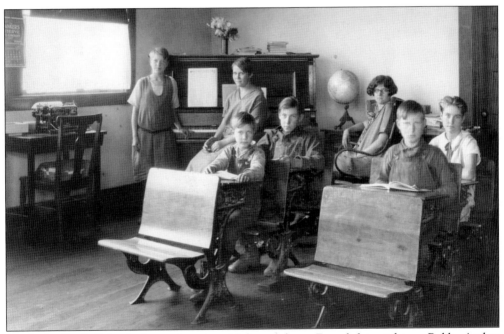

Inside the Corfu School, the teacher sits with her students. From left to right are Bobby Archer (standing by piano), Grant Archer, Clint Anderson, unidentified, teacher Florence Watson, John Archer, and Mellie Archer. The school was used until about 1938. The building burned down in the early 1960s. (Courtesy of LouAnn Davis.)

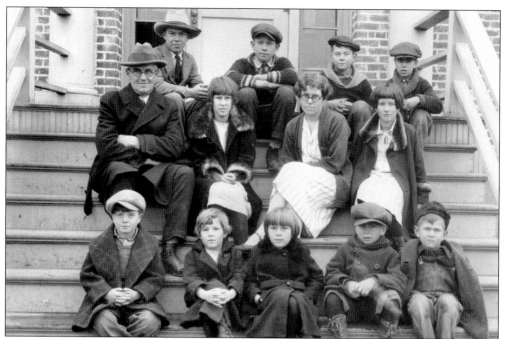

Smyrna, another railroad town along the Chicago, Milwaukee, and St. Paul Railroad, erected this school about 1928. Pictured are, from left to right, (first row) ? Gilbert, Lyla Johnson, Edith Johnson, John Schrom, and ? Gilbert; (second row) Superintendent Percy, Alice Johnson, teacher Mildred Williams, and ? Gilbert; (third row) George Johnson, Al Minniot, unidentified, and Robert Wylie. Although the school still stands, it has not been used since 1956. (Courtesy of JoAnn Pearson.)

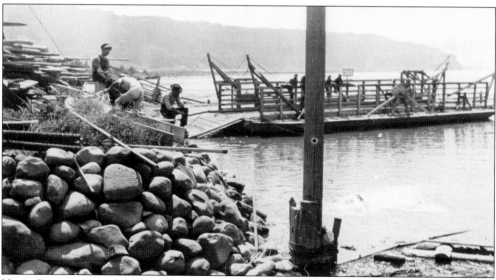

Henry Davies operated the Trinidad ferry between Grant County and Douglas/Kittitas Counties starting in 1910. Ferries had operated at this site since about 1900 to support sheep ranchers. In 1915, Davies replaced the original 18-by-60-foot cable ferry with this 22-by-60-foot barge. In 1930, he replaced the barge with a powered boat. Davies operated the ferry until the 1940s, supporting the fruit-growing regions in Grant County. (Courtesy of JoAnn Pearson.)

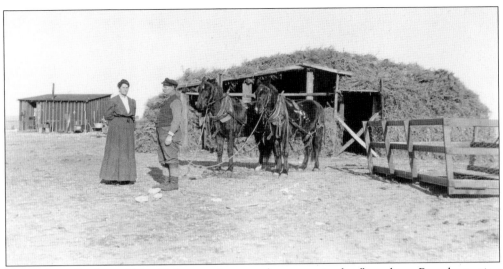

Pictured are Gordy and May Holman, who owned property in the flats above Beverly starting about 1906, before arrival of the railroad. Conditions were still primitive, as evidenced by the sagebrush livery stable. The family operated the ranch until their property was condemned by the federal government and used as a bombing range. (Courtesy of Raymond Grove.)

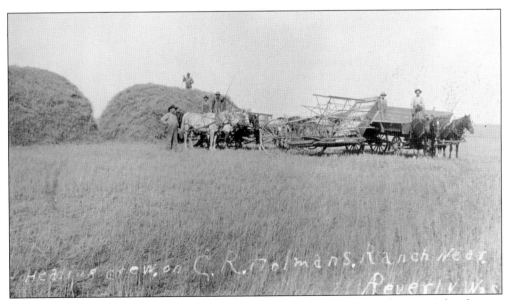

This heading crew works the wheat fields of the Holman ranch in the early years. A header cuts the grain and loads it into the header boxes. The wheat is then hauled to a central location in the field and stacked. Then the wheat was threshed at a few cents per bushel. (Courtesy of Raymond Grove.)

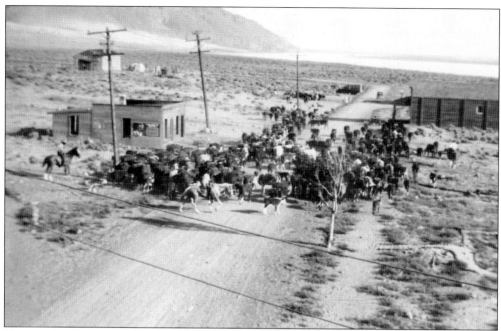

Here are the first cattle being driven through Beverly in 1934. The cattle belonged to the Clerf's Figure 2 Ranch. Elsie May Grove took this photograph from the second story of the Beverly Store, owned by T. R. Grove. The store burned down during World War II, but Grove rebuilt it in 1958. The building still stands but is abandoned. (Courtesy of Raymond Grove.)

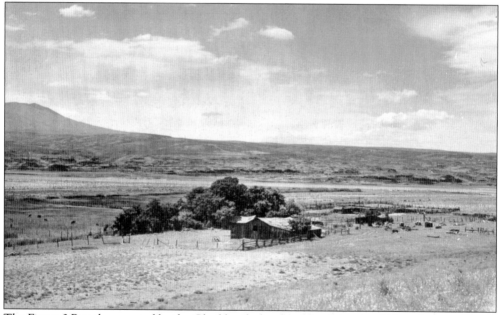

The Figure 2 Ranch, operated by the Clerf family, bordered land that would later become Desert Aire. The ranch was about a half a mile wide and 22 miles long. The Coffin brothers, who ranched all over the Columbia Basin, once owned the land. The Clerf Cattle Company, operated by Nicholas, Lawrence, and Edward Clerf, leased the property from Washington Irrigation in 1937. (Courtesy of Bud Clerf.)

The Clerf Cattle Company contained rangeland, pasture, and hay for their cattle. This early map shows the location of the Figure 2 Ranch and its proximity to the Columbia River and Yakima, Grant, and Benton Counties. (Courtesy of Bud Clerf.)

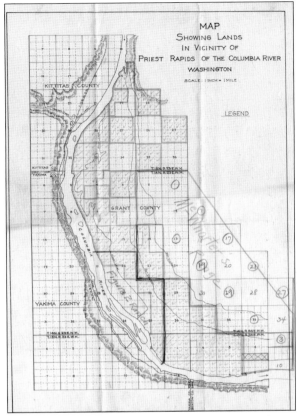

These early homesteaders settled in the Quincy Valley. The area had no trees of any kind; sagebrush and brunch grass seemed to be the only living plants. Droughts in the 1910s and 1920s forced many residents to give up their property and move away. (Courtesy of Quincy Valley Historical Society.)

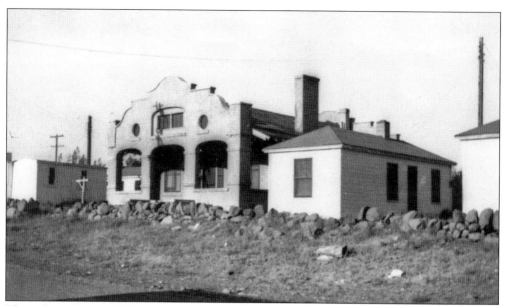

Throughout the 1910s, the Beverly Improvement Company occupied this building, which appears to have Spanish influence in its construction. (Courtesy of Raymond Grove.)

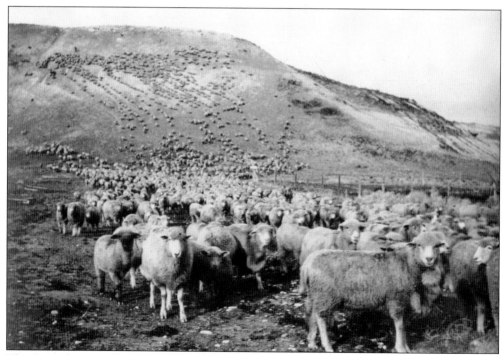

This large sheep herd was owned by the Brown Brothers and Fisk Company, operated by Win and Russell Brown and Bob Fisk. They bought the property in the early 1930s from A. D. Olsen. The sheep grazed the Wahluke Slope area. (Courtesy of Shirley Stewart.)

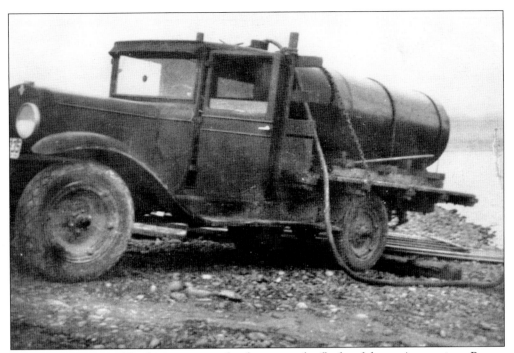

This truck was owned by the company to haul water to the flocks of sheep. At one time, Brown Brothers and Fisk Company raised 800 cows and 3,000 sheep and grew hay. The company was sold around 1956. (Courtesy of Shirley Stewart.)

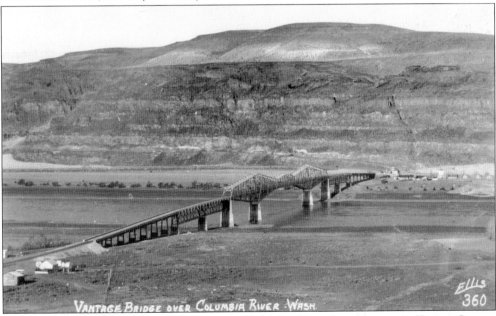

VANTAGE BRIDGE OVER COLUMBIA RIVER - WASH.

ELLIS 360

This is the first bridge that was built across the Columbia River from Vantage in Kittitas County to Grant County. A series of ferries had previously operated at this site. The two-lane bridge opened on September 8, 1927, and would stand until increasing automobile traffic necessitated the building of a new, four-lane bridge, which opened in 1962. The buildings seen on the Grant County side (background) have all been torn down. (Courtesy of Elizabeth Gibson.)

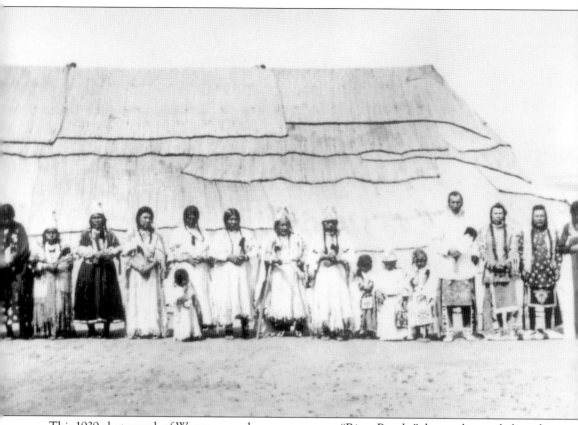

This 1939 photograph of Wanapums, whose name means "River People," shows what are believed to be the last full-blooded Native Americans of this tribe. They lived in villages constructed of tule mat A-frame homes on both sides of the Columbia River. They dug roots in the Ephrata/ Soap Lake area in the spring, fished at Priest Rapids, and held sacred ceremonies in the Saddle Mountains. This tribe never signed a treaty with the United States. In the 1950s, Grant County PUD officials worked with them to protect burial grounds and other sacred areas. (Courtesy of Grant County PUD.)

Two

EPHRATA
THE COUNTY SEAT

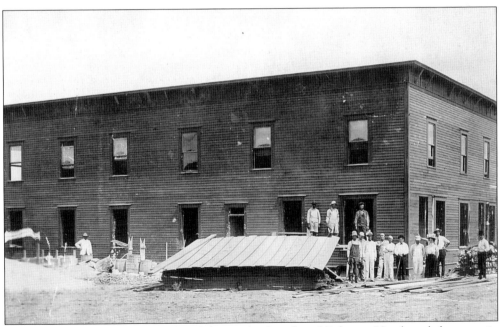

Jesse Cyrus is generally credited with being the founder of Ephrata. He platted the town in 1901 from land purchased from the Great Northern Railroad. A school district was formed in 1902, and a year later, there were close to 100 people living in Ephrata. The G. W. Harris Hotel, under construction here in 1907, was one of the first major hotels. (Courtesy of Grant County Historical Museum.)

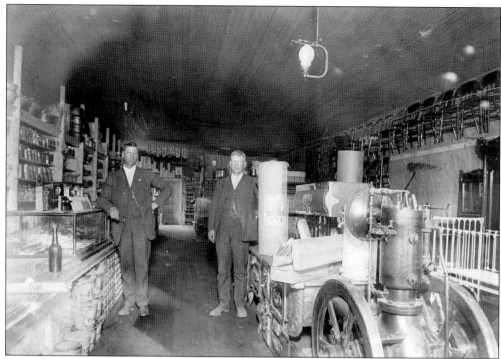

Pictured in 1908 is Ephrata's first hardware store, owned by Walter Davidson (left) and Dwight Chaffe. (Courtesy of Grant County Historical Museum.)

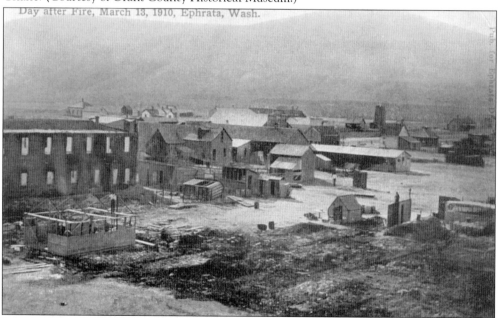

Day after Fire, March 13, 1910, Ephrata, Wash.

Ephrata suffered from a devastating fire on March 13, 1910. The fire started at John Erickson's saloon and spread in both directions. Citizens from Wilson Creek, Quincy, and Wenatchee helped fight the fire, and the Great Northern Railway assisted in bringing men and material to Ephrata to also help combat the flames. Two hotels, a restaurant, and several buildings, valued at $44,560, were lost. (Courtesy of Grant County Historical Museum.)

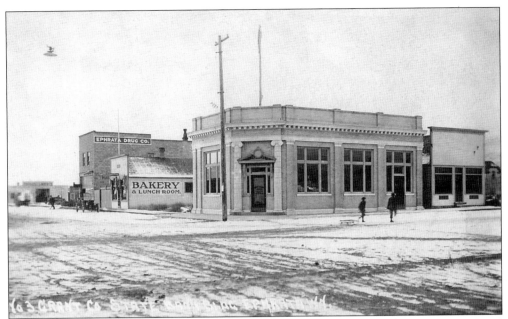

The Grant County Bank, owned by E. C. Davis, looked like this in 1918. The bank specialized in farm loans and fire and life insurance. Next to the bank are a bakery and lunchroom. The Ephrata Drug Company sits to the left of the bakery. In 1923, Davis and his cashier, Harry C. Erickson, would be indicted for embezzling, and the bank would be closed down. (Courtesy of Grant County Historical Museum.)

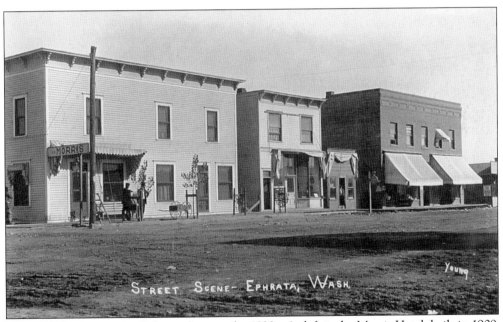

This early street scene in Ephrata dates to the 1920s. At left is the Morris Hotel, built in 1909, by Miss M. J. Morris. The 30-room hotel was considered the most modern hotel in the county at the time it was built. It was later moved to the eastern side of town and renamed the Cascade. (Courtesy of Grant County Historical Museum.)

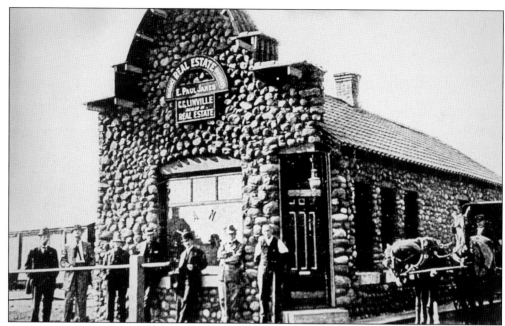

E. Paul Janes built this real estate office in Ephrata in the 1910s, but left the area a few years later. The building was later used by Rufus Woods, Billy Clapp, and others when they met to discuss the building of Grand Coulee Dam. The building has also been used as a saloon. The building, which still stands on Basin Street across from the post office, is in the process of being remodeled. (Courtesy of Mick Qualls.)

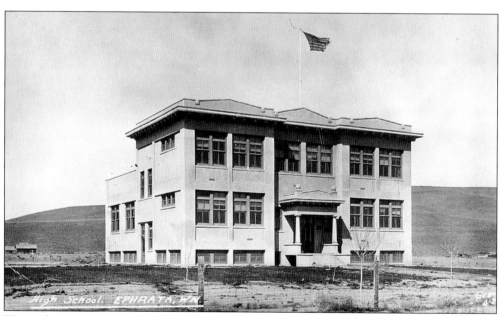

This is the first high school built in Ephrata. The first class graduated from Ephrata High School in 1914. (Courtesy of Grant County Historical Museum.)

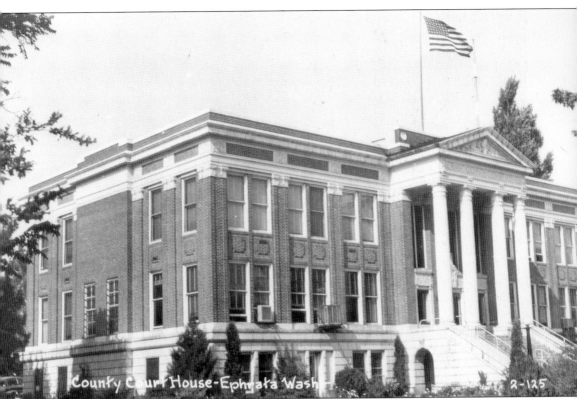

County Court House-Ephrata Wash. 2-125

The first courthouse, built by J. O. Cunningham, was constructed shortly after Ephrata became the county seat in 1909. The original structure, a two-story frame building, was 40 by 60 feet and cost about $5,000. That courthouse was replaced with this one, completed in 1918 on First and C Streets. Ground was broken in May 1917 and county officers moved in the following January. The final cost was approximately $64,000. The building was geothermally heated by a nearby hot spring. This courthouse still stands at the same location on C Street, and in 1977, it was added to the National Register of Historic Places. (Courtesy of Elizabeth Gibson.)

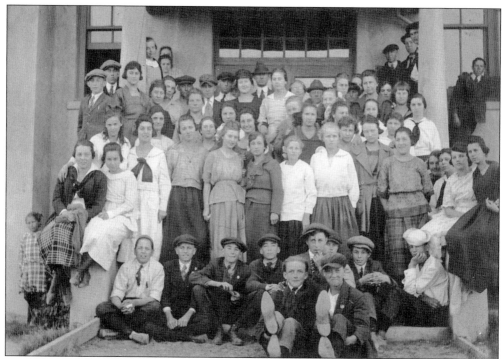

This 1923 photograph, taken on the steps of the main high school building, shows the entire student body of Ephrata's grade and high school. (Courtesy of Grant County Historical Museum.)

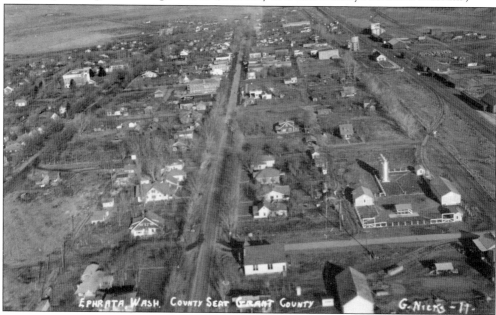

This aerial view dates from the 1930s when Ephrata was still a small agricultural town with a railroad depot. Until the military came in 1939, the town only had a population of about 700. This view is from the south looking north, with Basin Street shown in the middle. Basin Street had many trees at the time, but they were later removed as the town grew. The courthouse can be seen at center left. (Courtesy of Mick Qualls.)

This 1940s view of Ephrata's Basin Street looks south from Division Street. The first two buildings on each side of the street are still standing. On the left, the brick building is occupied today by Hair Klips. All Aboard for Travel and the Sun Basin Plaza stand to the south. On the right, the old Grant County Bank building is occupied by Sweet Bee Creations. Gift shops and restaurants stand to the south of it. (Courtesy of Grant County Historical Museum.)

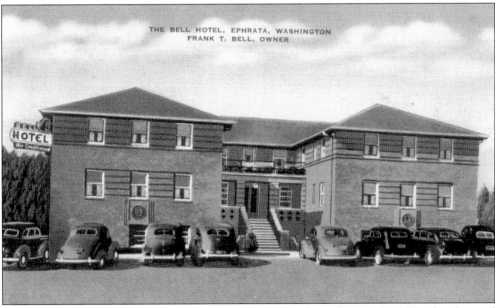

Frank and Bertha Bell built the Bell Hotel, which opened in February 1938. The hotel served both construction workers building Grand Coulee Dam and military personnel who later came when the Ephrata Air Base was established in the 1940s. Bell served as commissioner of the U.S. Department of Fisheries under Theodore Roosevelt. His son-in-law and daughter, Ben and Mabel Thompson, later took over operation of the hotel. (Courtesy of Elizabeth Gibson.)

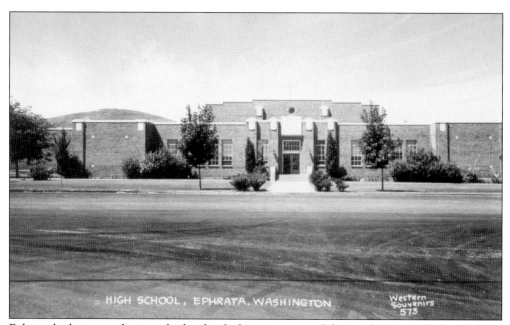

Ephrata built yet another new high school; this one was used during the 1940s. Today the high school, junior high school, and elementary school all share the same complex on Fourth Avenue. (Courtesy of Elizabeth Gibson.)

Pictured in the 1950s is John R. Kelly, Ephrata's first teacher, who began teaching in 1903. He also owned a grocery store with his partner, Tom Cook. (Courtesy of Grant County Historical Museum.)

Charles Wells began construction on Columbia Basin Hospital in August 1939 and finished by 1940. The building was one and a half stories with 17 beds, an emergency room, a surgery, and a delivery room. It is located at the corner of McMillen Avenue and Fourth Street on land donated by Ben Harvill. Forrest Rothrock was the first manager of the hospital. Wells also built the Old Folks Home and the Bell Hotel. (Courtesy of Grant County Historical Museum.)

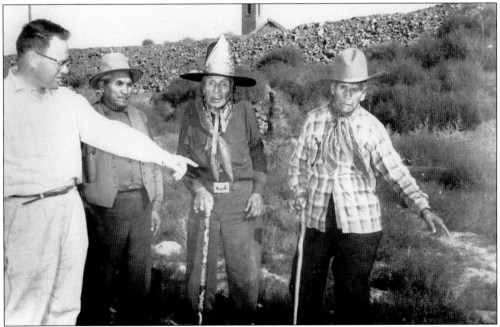

Pictured around 1956 is Billy Curlew (far right), a Sinkiuse Indian, who was born near Ephrata in the late 1860s or early 1870s. Here he points out to Nat Washington (left), an Ephrata attorney, the place where he was born. Also pictured are interpreter Harry Nanamkin, who translated both the Salish and Sohaptin languages, and Cleveland Kamiakin, who spoke the Sohaptin language. Curlew spoke the Salish language. (Courtesy of Grant County Historical Museum.)

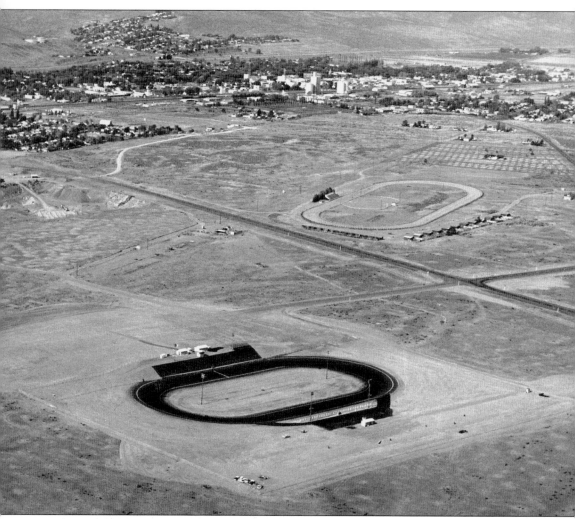

Ephrata Raceway, located southeast of town, began operation in 1970. It was considered the fastest quarter-mile track in the West in its early days, then later, the fastest track in the Pacific Northwest. The Columbia Basin Racing Association ran the pits, and stockholders Lawrence and Marie Borck handled the front gate, stands, and concessions. Later the Borcks become sole owners. In 1990, Dick Boness bought the track and introduced new classes of cars. It is now known throughout the state for open wheel racing. (Courtesy of Grant County Historical Museum.)

Three

MOSES LAKE

A horse trader named Parker is generally credited with being the first white settler in the Moses Lake area. The town was first called Moseslake, then Neppel, which name it kept until 1938. Pictured around 1906 are John and Sophia Hochstatter and their young sons John (b. 1903) and Chris (b. 1905). The Hochstatters were one of the first families in Neppel. (Courtesy of Harold Hochstatter.)

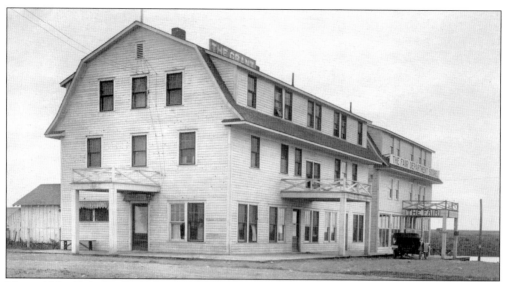

Mr. and Mrs. F. A. Ott built the 50-room Grant Hotel in Neppel around 1912, on the Southwest corner of Broadway and Ash Streets. Loren and Margaret Harris took over operation of the hotel in 1922 and built new sidewalks (the old ones had been ruined by livestock driven through town) and planted new trees. Harris renamed it Moses Lake Inn and added a café and a post office. (Courtesy of Harold Hochstatter.)

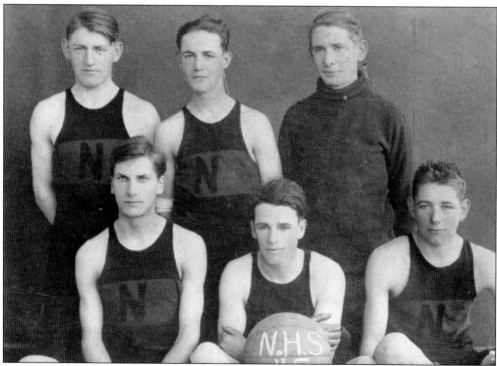

Neppel High School was built around 1913. By 1915, the high school fielded this basketball team. Pictured are, from left to right, (first row) Ed Landers, Ralph Secrest, and Glen Rinehart; (second row) Ed Harris, Don Ewald, Wood Harris (coach and uncle of Ed). (Courtesy of Moses Lake Museum and Art Center.)

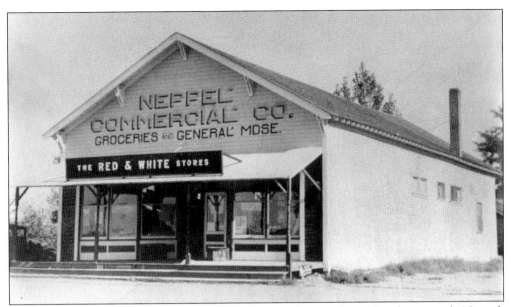

The Neppel Commercial Company sold groceries and general merchandise in early Neppel, operating from around 1911 to 1938. It was part of the Red & White grocery store chain. Emil Rudlof and Ed Leland, who owned many early Neppel properties, once operated the store. The building was sold in the early 1940s to Charles McCosh, future mayor of Moses Lake. (Courtesy of Moses Lake Museum and Art Center.)

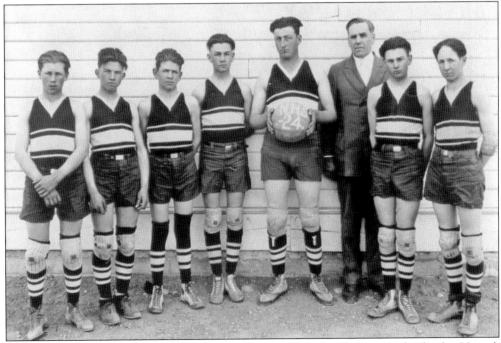

The 1924 Neppel High School basketball team represented the first four-year high school in Neppel. From left to right are Harold Eccles, Russell Hanson, Dan Rough, Paul Geffin, Edward Hull, Ben Randall King (coach and superintendent), Delbert Goeffrey, and Volmer Winn. (Courtesy of Moses Lake Museum and Art Center.)

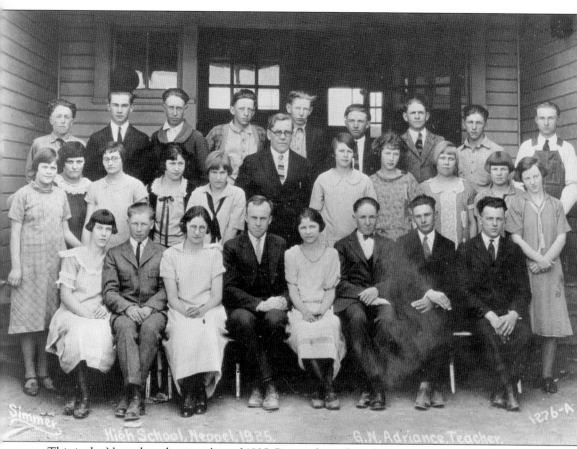

This is the Neppel graduating class of 1925. Pictured are, from left to right, (first row) Margaret Zickler, Harold Eccles, Lurley Richards, George Adriance (teacher), Gladys Richards, Velmer Winn, Delbert Guffin, and Clive Johnson; (second row) Ruth Nance, Minnie Sullivan, Josephine Sparks, Bertha Hochstatter, Marie McCoy, Ben Randall King (superintendent), Evelyn McCoy, Carol Walgomott, Christine Johnston, Bertha Eccles, and Doris Johnson; (third row) Floyd Hill, Paul Guffin, Harold Hill, Amos Hull, Earl Walgomott, Russell Hanson, Dan Raugh, John Becker, and Allen Sharp. (Courtesy of Moses Lake Museum and Art Center.)

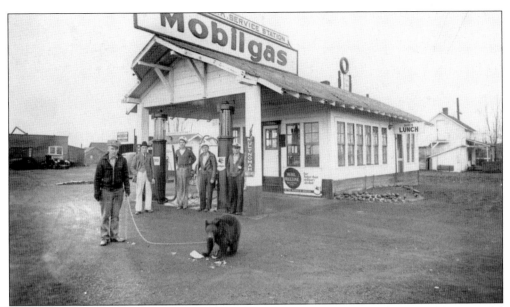

The O. K. Service Station, owned by the Ottmar brothers, was located at Broadway Avenue and Alder Street in Neppel. Pictured from left to right around 1930 are C. K. Burress with Susie the Bear, M. R. Burress, Dick Zickler, Richard Ottmar, and Emmanuel Ottmar. The building later became the home of Standard Batteries. (Courtesy of Moses Lake Museum and Art Center.)

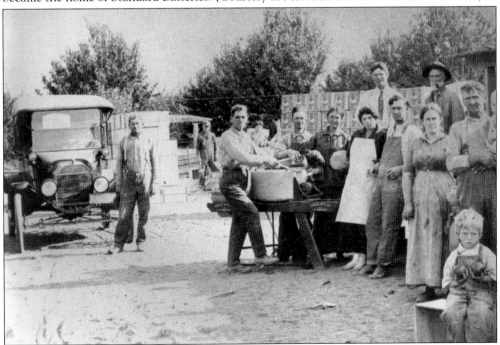

These workers take a break at the Jacob Secrest Orchard, an apple orchard in Cascade Valley west of modern-day Moses Lake. Secrest came to the Neppel area in 1910. He bought 40 acres for $100 each. Electrical power came to the Moses Lake area in 1922, powering irrigation pumps that made it easier to water orchards such as this one. Apples were an important crop into the 1930s. (Courtesy of Moses Lake Museum and Art Center.)

Looking more like a home than a house of worship, First Presbyterian Church was one of the early congregations in Neppel. Rev. Vernon Pastor conducted church services here. This photograph was taken approximately 1935. (Courtesy of Moses Lake Museum and Art Center.)

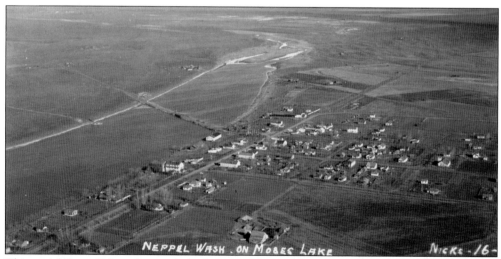

This aerial shot of Neppel was taken about 1937 by Gordon Nicks, a former sheriff and county commissioner. This area was located on the peninsula between the Parker Horn and the Pelican Horn of Moses Lake. The following year, Neppel reincorporated as Moses Lake, and Eric Peterson was elected the first mayor. He served until 1942. (Courtesy of Glen and Valerie Thiesfeld.)

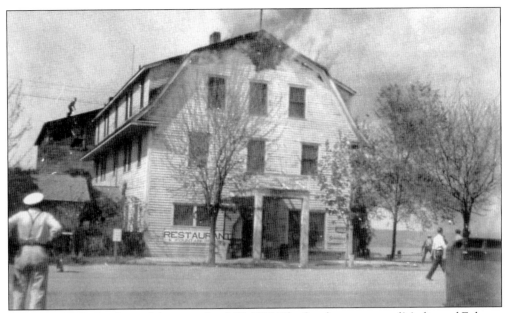

The Moses Lake Inn burned down on April 29, 1939. The fire departments of Marlin and Ephrata aided the Moses Lake Fire Department, but the building was a total loss. At the time, the post office had been maintained at the end of the building. Afterward the post office was temporarily moved to a small house. The hotel was not rebuilt, but instead a restaurant was built on that location. (Courtesy of Harold Hochstatter.)

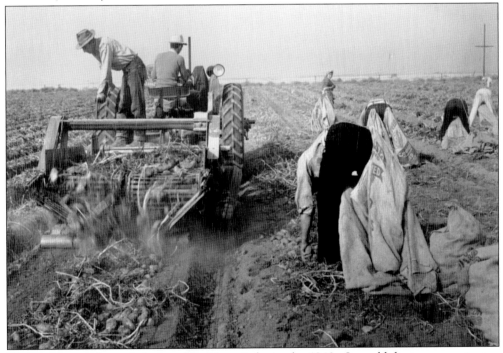

This is a potato digger being used in Moses Lake in the 1940s. It could dig two rows at once and throw the potatoes together to aid harvesting. The pickers carry extra sacks on their belts. (Courtesy of Moses Lake Museum and Art Center.)

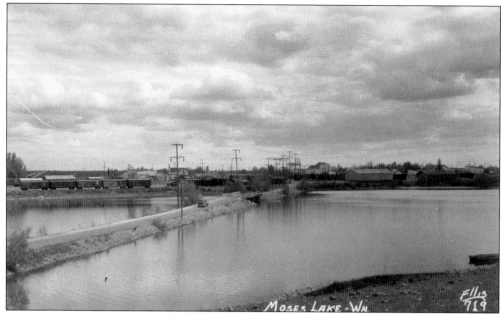

Pictured in the 1940s is the Alder Street fill, opened to traffic in December 1924. Despite the relatively dry climate, the area was still subject to flooding. The fill helped control the flooding, plus added a welcome thoroughfare to different parts of town. (Courtesy of Moses Lake Museum and Art Center.)

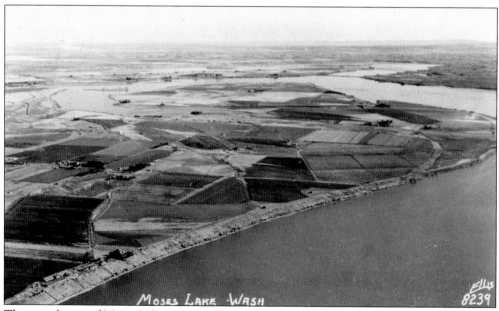

This aerial view of Moses Lake was taken just a few years after it had reincorporated under the name of Moses Lake. This photograph is of the main body of the lake, looking south. The large home at bottom left is that of Frank Bell. (Courtesy of Moses Lake Museum and Art Center.)

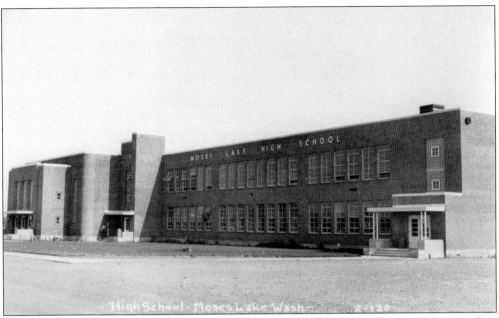

Moses Lake High School on Third Avenue opened in 1947. Considered state of the art when it opened, it included six modern kitchens for home economics classes and a full photography laboratory. When the high school moved to a new location in 1960, this building became Frontier Junior High. (Courtesy of Elizabeth Gibson.)

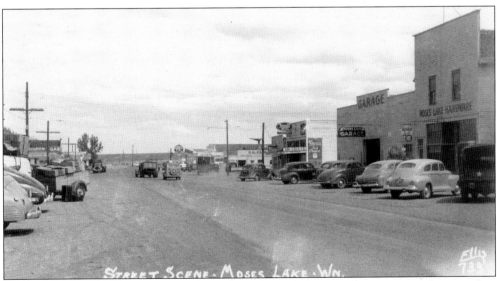

This section of Broadway developed around the old Neppel area. The photograph was taken in the early 1940s, after the military arrived to begin training at the nearby air base. At the time, the city still had dirt streets and wooden sidewalks. Moses Lake Garage and the Moses Lake Hardware Store on the right were owned by George Hochstatter. (Courtesy of Moses Lake Museum and Art Center.)

This view of downtown Moses Lake looks west down Broadway Avenue at Division Street. It captures a 1940s small town, though it does boast a very wide street. The town had seen some growth due to the nearby army air base, and new businesses began to create a downtown. (Courtesy of Moses Lake Museum and Art Center.)

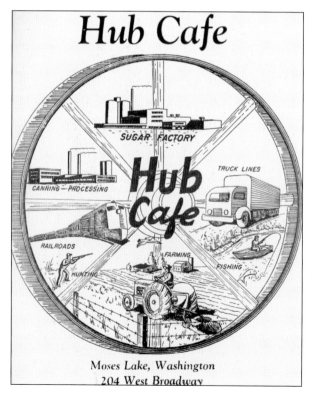

The Hub Cafe in downtown Moses Lake was a favorite restaurant for the locals. It opened in the 1950s and stood for many years on Broadway Avenue. The menu depicted how Moses Lake was at the crossroads and considered itself the center of the county, where agriculture, transportation, and recreation all came together. (Courtesy of Moses Lake Museum and Art Center.)

Four

QUINCY

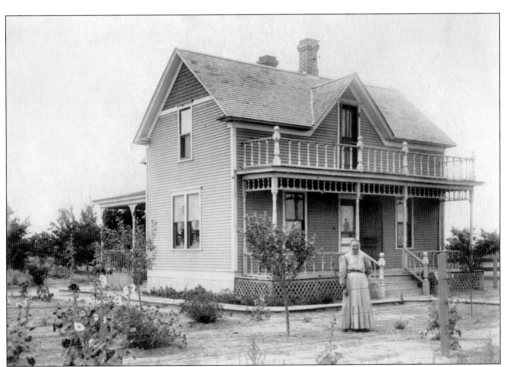

The Great Northern Railroad created Quincy Siding in 1892, and Richard Coleman platted the city of Quincy in 1902. Many of Quincy's early pioneers were Germans from the Dakotas, such as Jacob and Anna Schorzman, who brought their extended family to the area in 1902. Pictured is the home of their son, William Schorzman, on Road 5 near Quincy. At the time, this part of town north of the railroad tracks was known as Central Quincy. (Courtesy of Quincy Valley Historical Society.)

One of the first couples of Quincy were Samuel and Katherine Reiman, who is pictured here with her son Samuel around 1904. The Reimans built a large farmhouse on F Street. Calvin Blanchet bought the house in 1925, and his son-in-law Loren Simmons later occupied the home. Simmons willed the house to the city in 1995. Since 2001, the Quincy Valley Historical Society has leased the house from the city. (Courtesy of Quincy Valley Historical Society.)

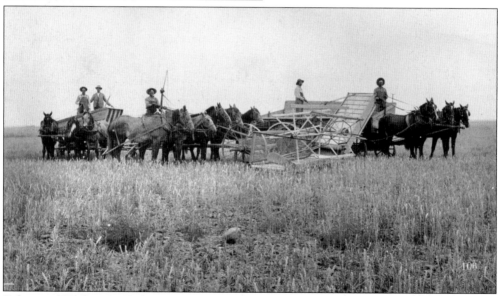

Balsar and Katharine Hieb came to Quincy with the Schorzman family. The Hiebs built a substantial home from locally made brick. About 1903, Hieb joined Philip Schatz, one of his brothers-in-law, in managing a general store. In 1904, they opened a larger store and used the original as a storeroom. He also owned this property, pictured around 1910, which he leased to Emmanuel Schulz. Balsar died in 1943, and Katharine died in 1944. (Courtesy of Quincy Valley Historical Society.)

Emmanuel (1876–1962) and Sophie Schulz (1881–1980) filed a homestead claim near Quincy in 1903. Sophie was yet another of the Schorzman clan. (Courtesy of Quincy Valley Historical Society.)

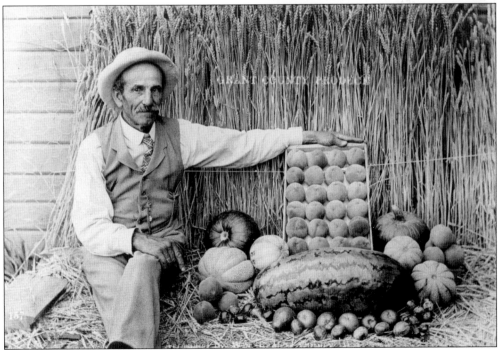

William Ragless and his wife, Mary Jane Symonds, moved to Quincy in 1893. He owned 2,000 acres of land and was one of the first to recognize the possibilities of irrigation in the Quincy area. Ragless was a charter member of the Quincy Valley Water User's Association, which organized in 1908. He was also involved in the real estate business in the Quincy district. Mary died in 1931, and William died in 1941. (Courtesy of Quincy Valley Historical Society.)

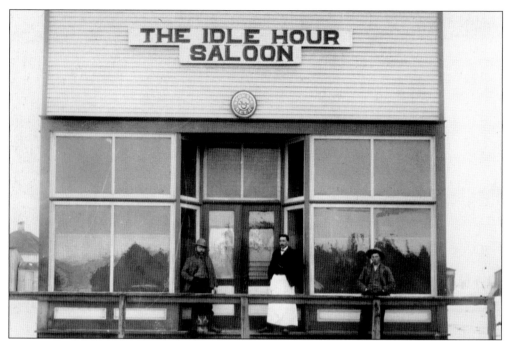

The Idle Hour Saloon was one of the first saloons in the area. John Heuther purchased the building in 1906, and in 1910, he moved it a block down the street. In 1917, E. A. Niblack converted it to Bob Seale's Pastime Pool. He added an ice cream parlor in 1919 because of Prohibition. After that era, it became known as the Spud Shed. Today it is the Idle Hour Café and Steakhouse, owned by Gene and Rhonda Rosenberger. (Courtesy of Quincy Valley Historical Society.)

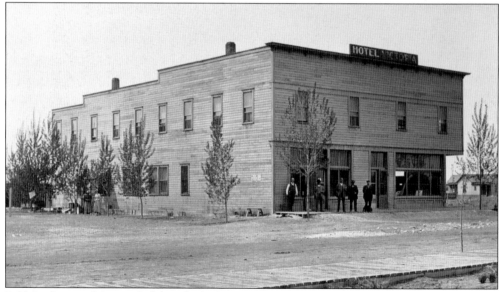

Fidd Cochran and August Sallsberg built the Hotel Victoria in Quincy in 1906 at a cost of $10,000. The hotel had steam heating and, after 1907, gaslights. Mr. Risedorf was the first manager. The hotel had been closed for several years when Mr. and Mrs. R. E. LaPierre reopened it in 1920, with Wendall Phillips in charge. The hotel burned down in 1929. A post office was erected at that location on B Street. (Courtesy of Quincy Valley Historical Society.)

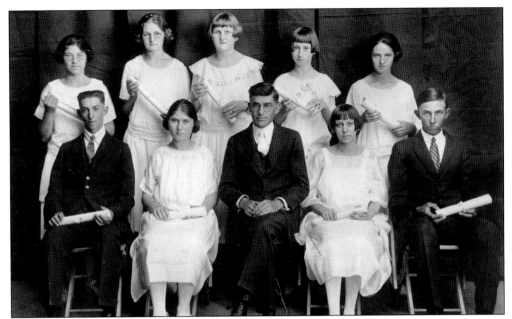

This early photograph of the Evangelical Reformed Church shows a confirmation class. Pictured are, from left to right, (first row) ? Yerke, Martha Weber Wahl, Pastor Jasmen, Minda Stollor, and Art Schorzman; (second row) Naomi Schatz, Hannah Weber, Lucy Schempp, ? Yerke, and Lydia Ruduner. (Courtesy of Quincy Valley Historical Society.)

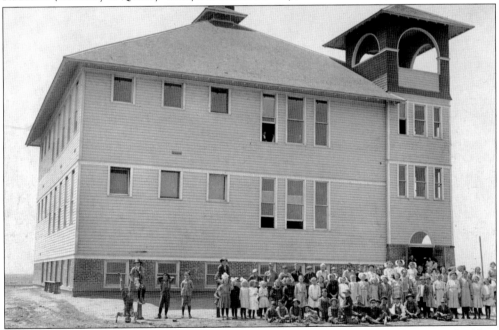

This Quincy school opened in 1907, the same year Quincy incorporated. The three-story building had six classrooms, a library, and a shop room. The first principal was Karen Gilbertson. The entire student body is shown on February 27, 1912. By then, the school had three high school teachers and four grade school teachers. The building stood near the present junior high school until 1940, when it was torn down. (Courtesy of Quincy Valley Historical Society.)

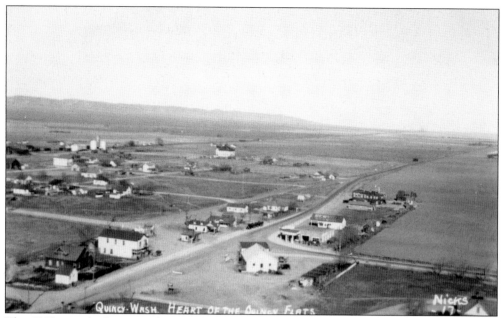

This 1930s view looking east shows early Quincy. The main road pictured in the lower left corner is State Highway 28, or F Street. The main cross street is State Highway 281, also known as Central Avenue. The large white building in the left foreground is the Shirley Hotel, and to the right of the building, across Central Avenue, is the Quincy Café. Across F Street from the cafe is the Whitener Ford dealership and service station. (Courtesy of Mick Qualls.)

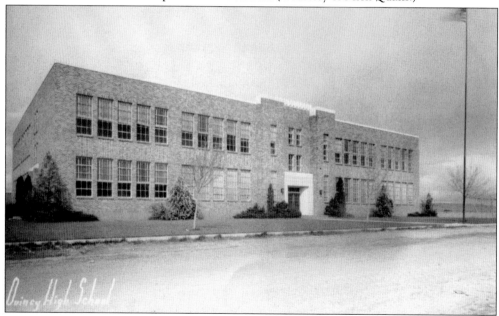

In 1938, this school was built on C Street at a cost of $90,000, and housed kindergarten through 12th grade. Continued growth required more schools, resulting in Pioneer Elementary School, completed in 1952, and Mountain View Elementary School, completed in 1954. A new high school was built in 1957. This building was used exclusively as a junior high school. It was expanded in 1961 and completely renovated in 1986. (Courtesy of Quincy Valley Historical Society.)

This is the entire Quincy High School student body in 1947. There were 41 students in the high school. At the time, L. C. Breen was the superintendent. (Courtesy of Quincy Valley Historical Society.)

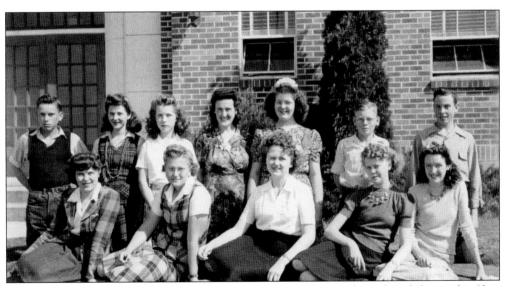

These young people represent the freshman class of 1948. Pictured are, from left to right, (first row) Darlene Petrie, Jody Wittkopf, Georgian Petrak, Betty Weber, and Dorothy Davies; (second row) Herbert Stites, Arlene Petrak, Patty Whitener, Mrs. Schorzman, Donna Prey, Edward Rau, and John Healy. (Courtesy of Quincy Valley Historical Society.)

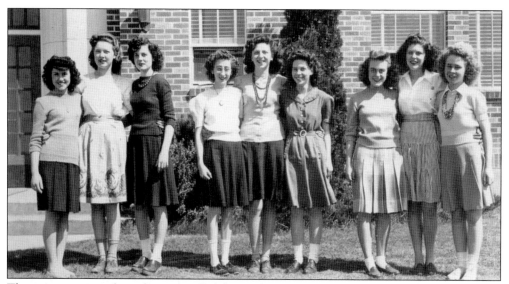

These young women formed a group called the Triple Trio, one of several such musical organizations at Quincy High School. Pictured from left to right are Esther Reiman, Madge Boyd, Lee Whitener, Burta Johnson, Marilyn Martin, Rosalie Whitener, Eleanor Huffman, Pauline Whitener, and Dorothy Weber. (Courtesy of Quincy Valley Historical Society.)

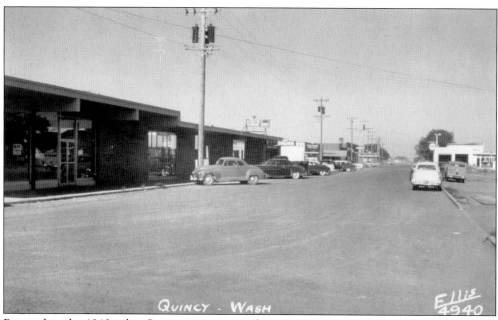

Pictured in the 1940s, this Quincy street scene shows E Street, one block off Central Avenue, looking east. The large building on the left side of the street still stands but is currently unoccupied. Farther down the street, Royer's True Value occupies a small building today, and on the right side of the street, Bank of America occupies this corner. (Courtesy of Glen and Valerie Thiesfeld.)

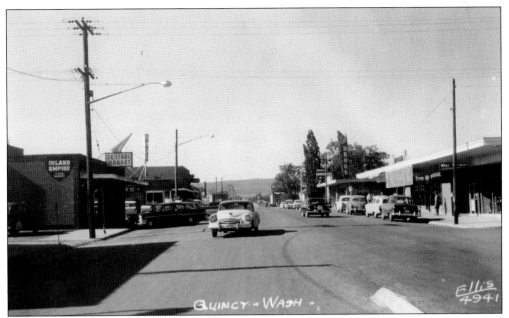

This Quincy street scene looks north from the intersection of Central Avenue and F Street during the 1950s. Many of these businesses no longer exist. Today Windemere Real Estate sits on the northwest corner (shadow at left), and Lemaster and Daniels sits next door. On the right side of the street, Bank of America occupies most of the block. (Courtesy of Glen and Valerie Thiesfeld.)

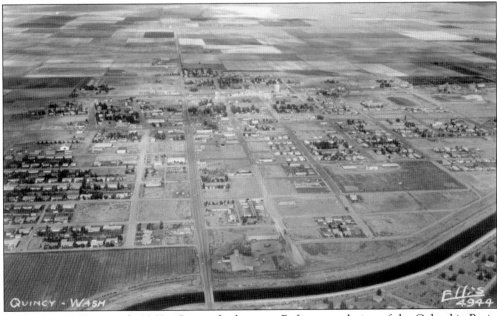

By the late 1950s or early 1960s, Quincy had grown. Before completion of the Columbia Basin Irrigation Project, Quincy had about 300 people. When water came, beginning in 1952, Quincy's population grew to about 3,000 in just three years. The West Canal in the foreground brought Quincy's water. State Highway 281 crosses the canal and continues north to the downtown. A patchwork of irrigated fields can be seen beyond the city limits. (Courtesy of Glen and Valerie Thiesfeld.)

The Quincy Valley Hospital opened about 1959. Pictured are Gene Weber and Larry Sievers. Several expansions later, the hospital still stands at Southwest Tenth Avenue. (Courtesy of Quincy Valley Historical Society.)

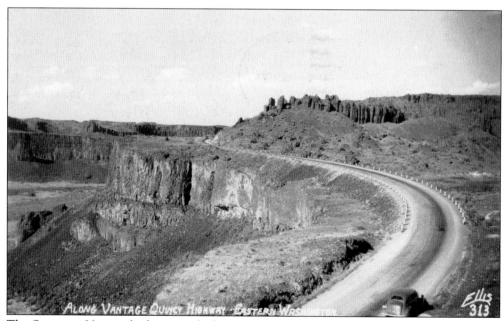

The Quincy to Vantage highway was little more than a wagon road for many years. Finally about 1947, the roadway was graded, and gravel was laid. A portion of the old road was known locally as Whiskey Dick Canyon. (Courtesy of Elizabeth Gibson.)

Five

SOAP LAKE

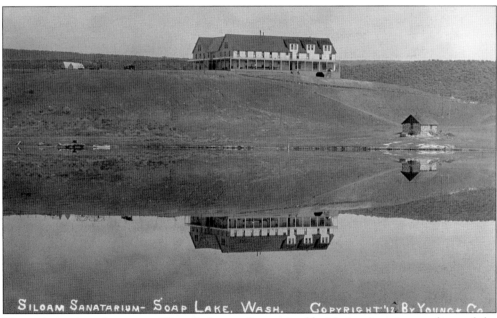

SILOAM SANATARIUM- SOAP LAKE, WASH. COPYRIGHT '12 BY YOUNG & CO

The unique mineral content of Soap Lake was first noticed by Native Americans, who used the water in their steam huts. Built in 1907, the three-story Siloam Hotel and Sanitarium was one of the first to take advantage of the lake's unique properties. O. E. Loving, M. R. McMann, and John Rogers financed it. The hotel operated for 14 years before it burned down on September 1, 1921. The owners did not have insurance. (Courtesy of Elizabeth Gibson.)

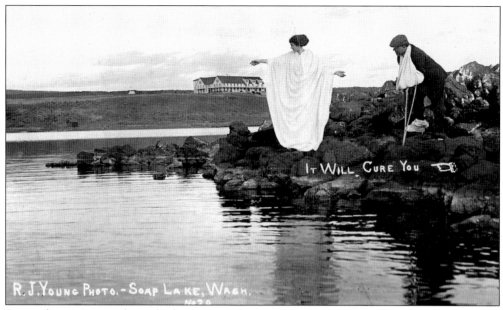

Soon advertisements about the healing qualities of Soap Lake appeared in newspapers across the country and in Europe. People began to flock to the area to relax, socialize, and soothe their ailments. The local residents believed in their product as evidenced by this advertisement of Soap Lake. The Siloam Hotel stands in the background. It was built high on a hill on the east bank of the lake with a commanding view. (Courtesy of Linda Bonneville.)

The Soap Lake Sanitarium took over the original Lombardy Hotel, which was built in 1905. This ad shows the goods and services provided by the Sanitarium. The business was one of the new that survived later fires. The sanitarium operated until 1945. (Courtesy of Kathy Kiefer.)

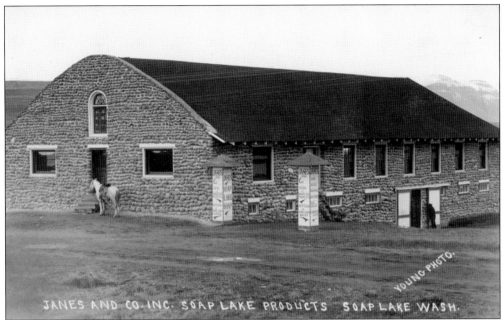

E. Paul Janes came to Soap Lake about 1910 and established his business, Janes and Company, Inc. Janes sold products guaranteed to cure various ills, including bottled Soap Lake water. He also built several buildings out of round river rock, such as this building that housed his business. By 1910, the population of Soap Lake was 352. (Courtesy of Kathy Kiefer.)

Analysis showed that Soap Lake water contained bicarbonate, sodium, sulfate, and several other minerals in various proportions. This combination was believed by many to be a miracle cure. Ads such as this one appeared in newspapers across the country, prompting visitors from as far away as Europe to visit Soap Lake. (Courtesy of Kathy Kiefer.)

DIRECTIONS FOR USING

SOAP LAKE

WONDER

THE GREAT BLOOD PURIFIER

For severe cases of Articular and Inflammatory Rheumatism use as a vapor bath. Take one part **Soap Lake Wonder** and one part fresh water, put in pan over alcohol stove under chair and cover patient with blanket to retain all the vapor. Use for 20 to 30 minutes and bath joints in **Soap Lake Wonder**, using it full strength and take internally one teaspoonful of **Soap Lake Wonder** in one full glass of fresh water. For Liver and Kidney trouble use as above directed. For blood diseases take internally as above directed, taking sponge bath, using one tablespoonful of **Soap Lake Wonder** to each quart of water.

Soap Lake Wonder is a highly concentrated preparation, one bottle being equal to several gallons of Soap Lake Water, and should NEVER be used FULL STRENGTH except as a liniment.

For Eczema, use cold, using one tablespoonful to one quart of water.

The Liquid Sulphur contained in this preparation, with the famous Soap Lake Water, makes an excellent blood purifier. As a bracer after excessive use of alcoholic liquor it will give great relief.

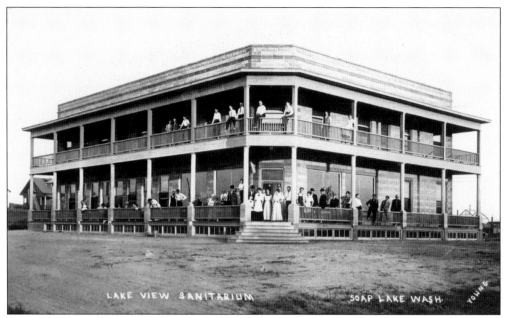

The Lake View Sanitarium opened on June 23, 1913, by George Krau, proprietor. The sanitarium, located at First Street and Main Avenue, had a doctor, bath attendants, steam heat, and electric lights, and it claimed to treat bowel conditions, liver disease, and kidney illnesses. The sanitarium burned down in 1924. (Courtesy of Gordon Tift.)

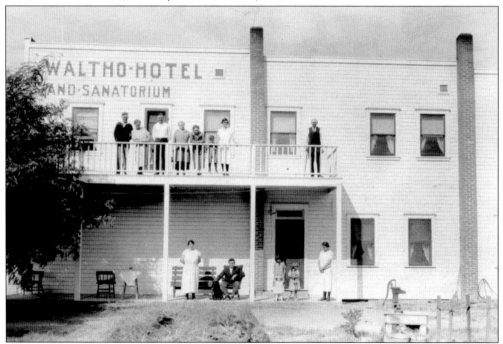

The Argonne Hotel was originally built in 1920 on Main Avenue. In 1923, George and Maggie Waltho came to Soap Lake to treat his asthma. The couple bought the hotel and renamed it the Waltho Hotel and Sanitarium. It was later converted to Barky's Hotel. (Courtesy of Waltho family.)

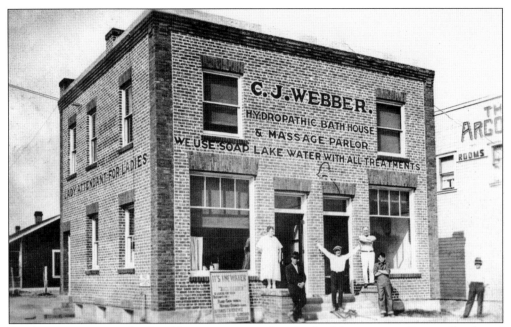

Besides sanitariums, other local businesses catered to the health conscious. Some offered mud baths, with the mud taken from different places on the shore and bottom of Soap Lake. Others, such as C. J. Webber, used the water that was thought to ease physical afflictions. Jack Webber also offered baths and massages. C. J. Webber stood next to the Argonne Hotel, which was renamed the Waltho Hotel after 1923. (Courtesy of Duane Nycz.)

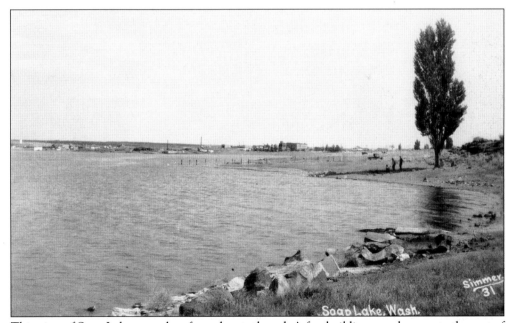

This view of Soap Lake was taken from the south end. A few buildings can be seen to the east of the lake, where most of the development was and still is today. The boom had not yet hit Soap Lake since docks and boardwalks had not yet been erected. (Courtesy of Elizabeth Gibson.)

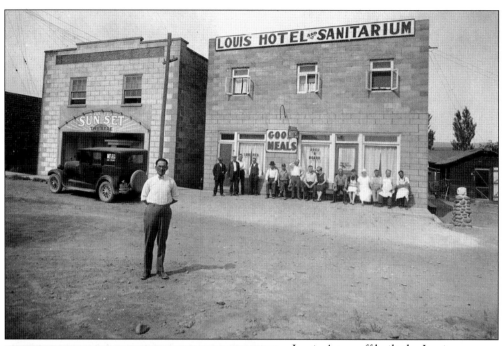

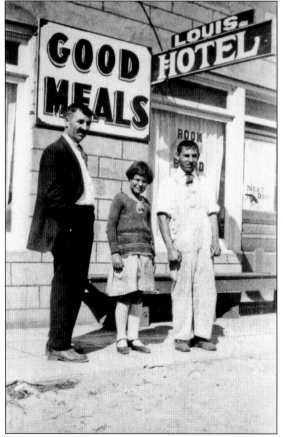

Louis Agranoff built the Louis Hotel and Sanitarium in 1919 out of cast concrete blocks. Located near the Sunset Theater and the dance pavilion, a porch ran the entire length of the hotel. It was particularly popular with Jewish visitors. (Courtesy of Agranoff family.)

This is another view of the Louis Hotel. In 1927, Louis Agranoff bought the Johnson Hotel in Ephrata, moved it to Soap Lake, and joined it to his existing hotel. (Courtesy of Agranoff family.)

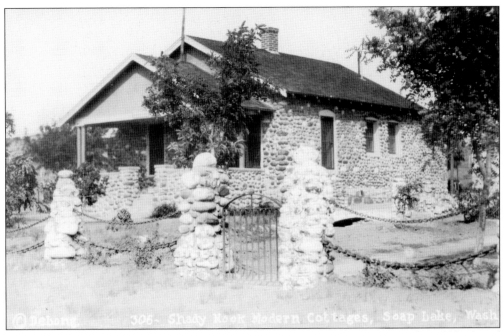

The sanitariums were so popular that hotels were quickly booked, and no rooms could be found anywhere. Entrepreneurs put up tent cities that were just as quickly rented. Other businessmen erected small cottages, such as the ones pictured, for visitors who intended a longer stay. This particular development was known as Shady Nook Modern Cottages. (Courtesy of Elizabeth Gibson.)

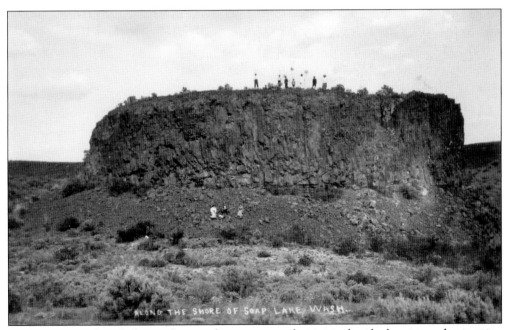

Some visitors to Soap Lake sought out other recreational activities besides boating and swimming on the lake. These visitors looked to the surrounding countryside to do a little hiking. Unusual rock formations are common in the vicinity of Soap Lake. (Courtesy of Elizabeth Gibson.)

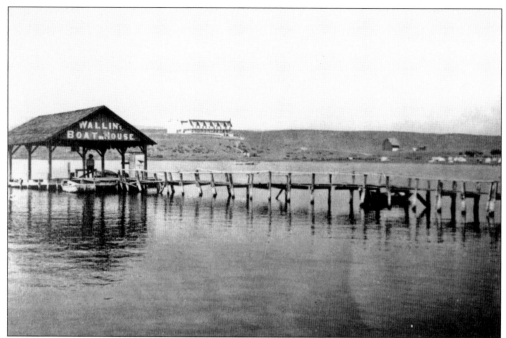

Gus Wallin erected a boathouse at the end of this walkway, built on the shores of Soap Lake. Wallin rowed a small boat out to the deepest part of the lake where he took samples from deep beneath the surface and sold it to local businesses that marketed the service as a "deep-sea bath." The deep water was higher in sulfur content than that at the shore. (Courtesy of Klasen family.)

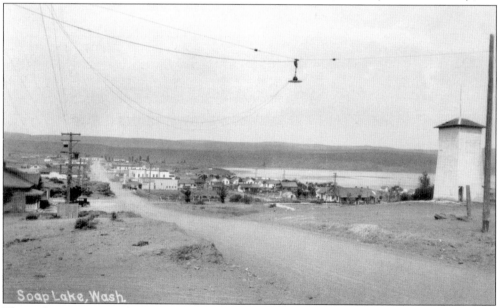

This is the main street of Soap Lake in the 1920s. Sanitariums and other health-related businesses were built to cater to people who came to Soap Lake looking for a cure from the lake's mineral waters. The Waltho Hotel and Thorson's Soap Lake Products can be seen on the distant right side of the street. Later a disastrous fire destroyed two of the sanitariums, and the Depression closed the rest. By 1930, the population of Soap Lake was 280. (Courtesy of Elizabeth Gibson.)

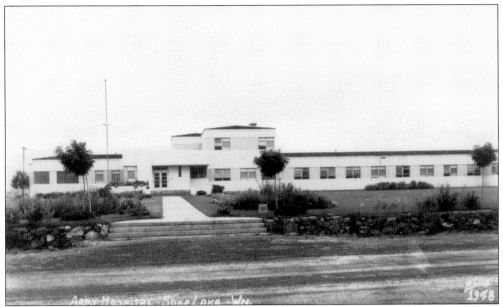

In 1932, the government studied Buerger's Disease, an ailment particularly prevalent to World War I veterans. The Earl McKay Memorial Hospital was established to treat patients with the illness. The hospital opened in October 1939 with a reception held on the lawn. Preference was given to Washington residents. The first patient was a local sportsman and civic leader named Sam Gorman. (Courtesy of Elizabeth Gibson.)

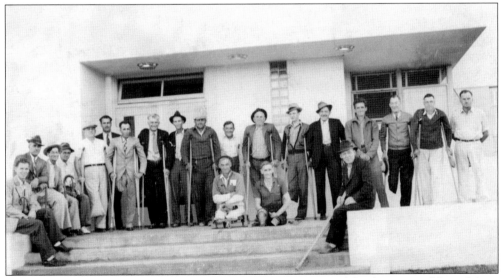

During the opening day celebration, these Buerger's patients posed for the camera. Most of these men had already lost limbs from the disease, which affects blood flow to extremities and causes them to become gangrenous, requiring amputation. During the 1930s, one in 18 visitors to Soap Lake had the disease. McKay Hospital was the only facility in the country that treated the disease. (Courtesy of Kathy Kiefer.)

Roxy and Ernest Thorson took over the Janes Soap Lake Products business, pictured in the 1940s, after Janes left in 1913. Roxy Thorson took over the business in 1920 when her husband died, and she ran the business until she passed away in 1984. The building was later converted into apartments. (Courtesy of Kathy Kiefer.)

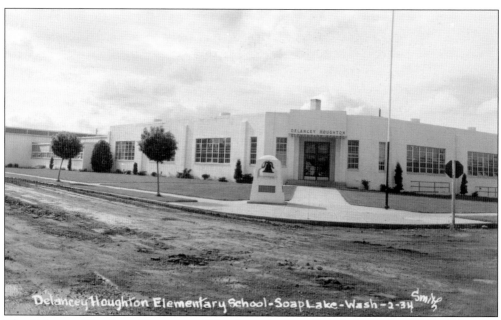

The Delancey Houghton Elementary School was built in Soap Lake in the 1940s. Note that the city streets are still made of dirt. Today the school is no longer in use and is scheduled to be demolished in the next few years. (Courtesy of Elizabeth Gibson.)

Six

SMALL TOWNS

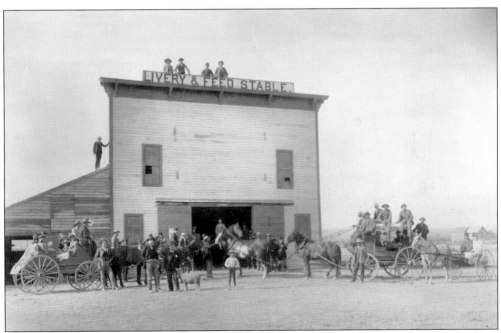

Coulee City is the oldest town in the county, originally called McEntee's Crossing. Phillip McEntee came to the area in 1877; he died in 1901. The area was the only natural crossing of the coulee and served as a roadway. This livery and feed stable was one of the first businesses, operating in 1889 in the original town of McEntee's Crossing. Later the local theater would stand at the same location. (Courtesy of Grant County Historical Museum.)

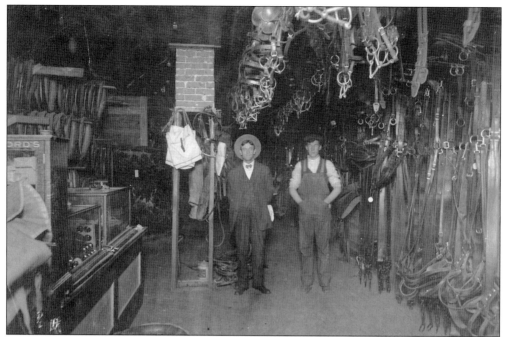

In 1890, Levi Salmon platted a new town that would be known as Coulee City about a mile south of McEntee's Crossing. The post office moved to Coulee City. In those days, men still traveled by horseback, and that made a harness shop such as this one an essential business. The younger man pictured is Tom Twining (born locally in 1889), who also worked in the general store. He would later serve on the county Board of Commissioners. (Courtesy of Grant County Historical Museum.)

These early residents have a picnic at the Coulee City Park in 1903. The park was situated at the south end of the Grand Coulee, long before it was filled with water pumped from Grand Coulee Dam. The city park still stands at the same location and is now a popular camping, boating, swimming, and picnic area on the shores of Banks Lake. (Courtesy of Grant County Historical Museum.)

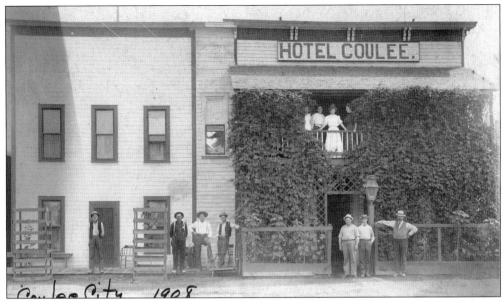

Pictured here in 1908, Hotel Coulee served Coulee City in the early days; there were plenty of people needing a comfortable place for an overnight stay. The Central Washington Railroad, a branch of the Northern Pacific, ran through Coulee City starting in 1890. An extension of the Great Northern Railway was built from Coulee City to Adrian in 1902. (Courtesy of Grant County Historical Museum.)

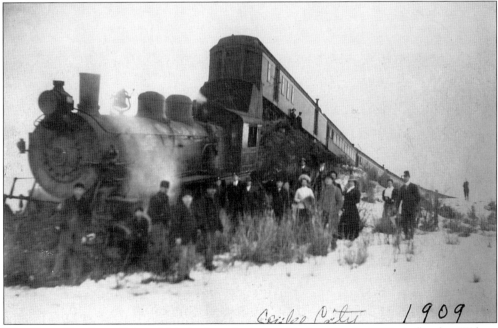

The Great Northern Oriental Limited crashed near Coulee City in 1909. A flood at Wilson Creek washed out the tracks and caused the train to be rerouted over the Washington Central Railroad to the Great Northern lines through Adrian. When the train passed through Coulee City, someone forgot to throw the switch and the train derailed on an abandoned Northern Pacific grade. (Courtesy of Grant County Historical Museum.)

Podey's Motel in Coulee City was built in the 1940s. By this time, a major highway, State Route 2, passed through Coulee City. Coulee City was about halfway between Wilbur and Waterville, a spot of civilization in an otherwise sparsely settled area. An overnight haven was essential for travelers. The motel was considered state of the art at the time with garages, steam heat, and electric ranges. (Courtesy of Elizabeth Gibson.)

A chain of small lakes lies between Coulee City and Soap Lake. This is Blue Lake, now on Highway 17 between the two towns. The lakes act as reservoirs of the Columbia Basin Irrigation Project and are quite deep only a few feet from the shore. The lakes also provide recreation for residents and visitors. (Courtesy of Elizabeth Gibson.)

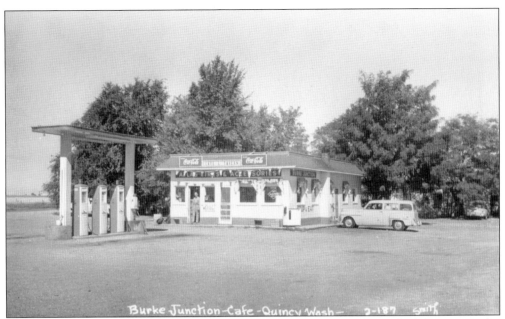

The town of George, Washington, was formed and named by Charles and Edith Brown, who bought 339 acres about 10 miles south of Quincy for $72,310. The Bureau of Reclamation had set aside the property, formally known as the Burke development, as a "company" town. At Burke Junction, near the modern-day intersection of Interstate 90 and State Highway 281, this lone gas station was erected. Today a gas station is all that stands at the place once called Burke. The town of George developed about one mile southeast of this spot. (Courtesy of Glen and Valerie Thiesfeld.)

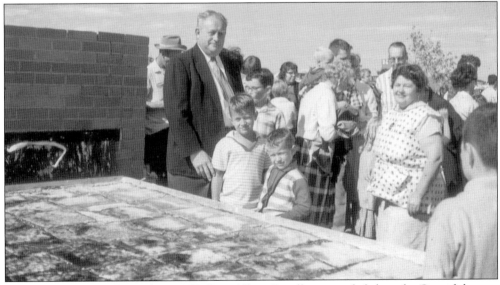

George was dedicated on July 4, 1957. Gov. Albert Rosellini attended the gala. One of the star attractions was an 8-by-8-foot cherry pie that used 125 pounds of flour, 100 gallons of cherries, and 200 pounds of sugar. Also, 800 pounds of roast beef were cooked and served on this huge tray. Brown and his grandsons, Kerry and Rick Bowles, are standing near the tray. (Courtesy of Rick Bowles.)

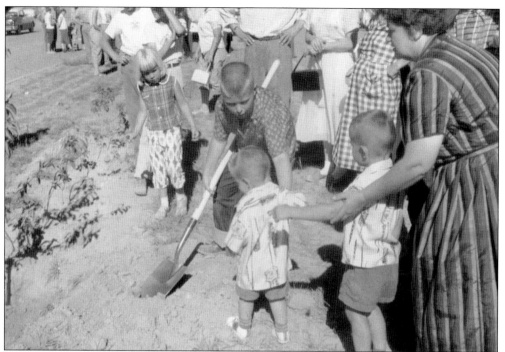

Part of the dedication celebration included the planting of cherry trees. Here Edith Brown and two of her grandchildren assist in planting the trees. (Courtesy of Rick Bowles.)

Charles and Edith Brown set about establishing the George Washington theme throughout the town and named several of the streets after different varieties of cherries. In 1958, they opened Martha's Inn and Gas Station. They later sold the inn to Mr. And Mrs. Virgil Schmoe, who subsequently sold it to Leslie and Alfred Strong, Edith Brown's brother-in-law and nephew. (Courtesy of Virginia Sheldon.)

Every Sunday, Edith Brown showed her hospitality by serving brunch at Martha's Inn. Pictured here one Sunday, the building was so crowded, it is possible that the entire town came to eat and socialize at this meal. (Courtesy of Virginia Sheldon.)

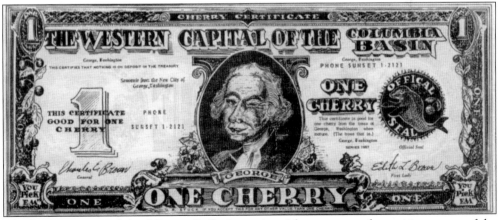

Charles Brown created this "George Dollar" as a gimmick to promote the positive aspects of the town. Somehow, the gag got the attention of the Federal Bureau of Investigation, and Brown was ordered to cease making the dollars. (Courtesy of Rick Bowles.)

George got its first shopping center in 1958. At the time it was built at the corner of County Road and Montmorency Boulevard, it was the largest brick building in the Columbia Basin—200 by 225 square feet for a total of 32,000 square feet. It had space for 12 to 15 businesses. (Courtesy of Virginia Sheldon.)

Pictured is Sherry Bowles at one of the many Fourth of July celebrations. The Browns were her grandparents. (Courtesy of Virginia Sheldon.)

Charles Brown was elected the first mayor when George was incorporated on July 18, 1961. He also maintained a large cherry orchard, operated a gift and import business in Honolulu, and managed a wholesale fireworks business. He held the office of mayor for 14 years, until he died in 1975. Edith Brown served the remainder of his term and was reelected for one 4-year term. She later served on the city council. Edith Brown died in 1997. (Courtesy of Virginia Sheldon.)

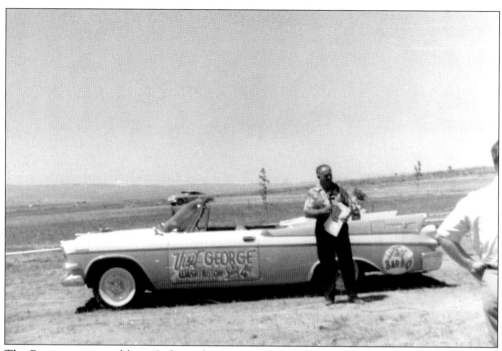

The Browns sponsored large Independence Day celebrations. This specially decorated car was used to promote the event. (Courtesy of Virginia Sheldon.)

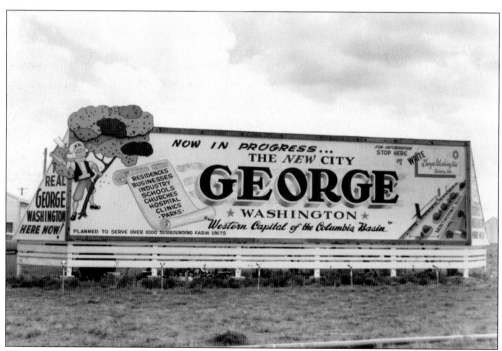

This sign advertising George was first built in Toppenish, while the Browns still lived there, just prior to moving. The sign stood for many years on the outskirts of town. (Courtesy of Virginia Sheldon.)

This aerial view of George shows its development in the early days. Many buildings have sprung up around Martha's Inn, yet the trees down the main street still remain quite small, and the highway going by has not yet been expanded to four lanes. (Courtesy of Virginia Sheldon.)

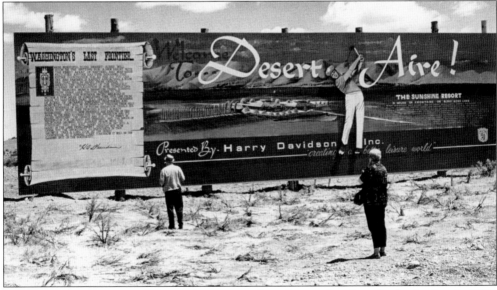

The planned community of Desert Aire was nothing but sagebrush at the beginning. In 1969, Marge McCormick, a Yakima realtor, offered the first 3,200 acres for sale. This sign was erected near the area. Harry and Ross Davidson bought the property for $1 million and began offering lots for sale in 1970. Charles Morgan and Associates of Seattle designed the complex. (Courtesy of Ross Davidson.)

Jack and Sheila Gleason came to Desert Aire in 1972. They were avid horse breeders and rodeo enthusiasts. They partnered with the Davidsons to build rodeo grounds at Desert Aire, and the Desert Aire Stables opened in 1973. The rodeo grounds were completed in 1974. (Courtesy of Ross Davidson.)

Don and Val Halbert first built a home in Desert Aire in 1971 and then built the first general store in the area, breaking ground on February 18, 1973. The store opened in August 1973 and still stands today. It offered groceries and catered to travelers going by on the highway. It also had a lunch counter. (Courtesy of Ross Davidson.)

Don and Val Halbert also operated the Desert Aire Chevron gas station. Harry Davidson purchased the gas station in Moses Lake and moved it to Desert Aire in the early 1970s. The Halberts bought it about 1973 and operated it for several years. The Perry family took over around 1985 and continued to operate it as a Chevron station. Bruce Perry currently operates the station, which is now part of the Shell chain. (Courtesy of Ross Davidson.)

The Desert Aire fire station was built in 1980 for about $12 million. The land was donated to Grant County Fire District No. 8 by the Desert Aire Owners Association. The original building was 32 by 42 by 14 feet. The station housed one ambulance, a rescue unit, fire engine, tender, and three wild land units. When opened, the station responded to 62 medical calls and 36 fire calls in the first year of operation. (Courtesy of Ross Davidson.)

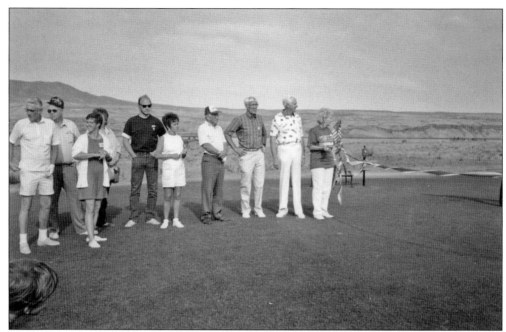

In June 1992, Desert Aire residents celebrated the opening of the "back nine" of their golf course; the original nine holes had opened in 1972. Golf course architect Jim Krause developed the remaining holes. From left to right are Clint Brunner, Lou Crocker, Kelsey Hyndman, Evelyn Newman, Del Christensen, Judy Davidson, two of the contractors who helped build the new golf course, Ross Davidson, and Lynn Davidson. (Courtesy of Velma Best.)

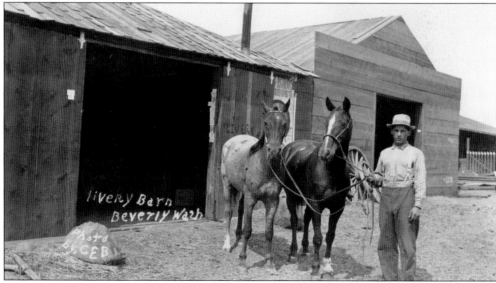

After the railroad was completed in 1909, the small community of Beverly began to develop around the depot. The Beverly livery stood just west of the main street of town. Liveries stabled horses being used for transportation and those of traveling salesmen and others who might be visiting the town. This photograph was taken by Cal Bradbury, an early Beverly resident. (Courtesy of JoAnn Pearson.)

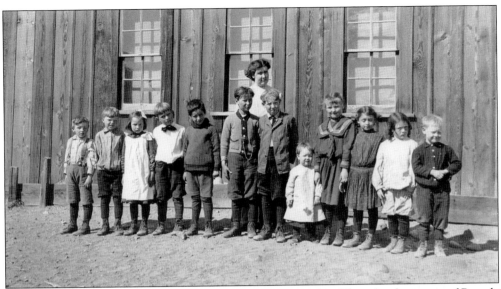

This is what the Beverly School looked like in the 1910s–1920s. The school was part of Beverly School District No. 86, the original district in the area. Later it was consolidated with Bend and Royal Flats schools. It is the only building left of the original town, and it is currently being used by the fire department. (Courtesy of JoAnn Pearson.)

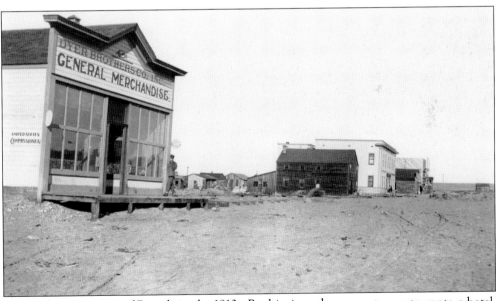

Here is the main street of Beverly in the 1910s. By this time, there were two restaurants, a hotel, lumberyard, and two or three small businesses. The Beverly Hotel is the two-story white building seen at the far end of the boardwalk sidewalk. The Dyer Brothers Store was bought by the railroad and turned into apartments. Later the pipes froze, and the building burned down around 1937. (Courtesy of JoAnn Pearson.)

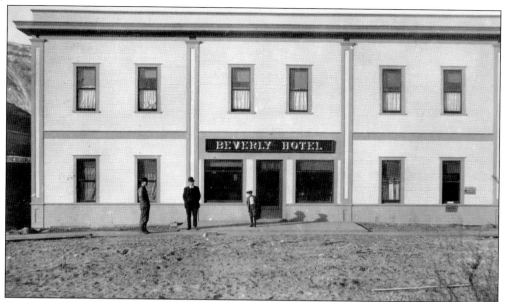

Pictured on Main Street is the Beverly Hotel, thought to have been built around 1910. Photographs of that year show it standing but unpainted. The Beverly Investment Company set up an office to help bring business to Beverly during the 1910s and 1920s. It cleared a tract 4 miles long and 1 mile wide along the shore of the Columbia River in anticipation of planting orchards. (Courtesy of JoAnn Pearson.)

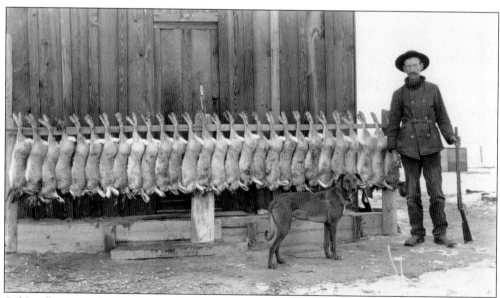

Cal Bradbury stands with a brace of rabbits at his homestead near Highway 26, in the 1920s. Rabbit drives were common in Grant County in the early days. Cal and his wife, Nina, homesteaded at Royal Slope and owned three homes in Beverly. Cal owned a gas station from 1921 until his death. Nina taught music, singing, and various musical instruments. Cal Bradbury died in 1955. (Courtesy of JoAnn Pearson.)

Seven

THE COUNTY BLOOMS

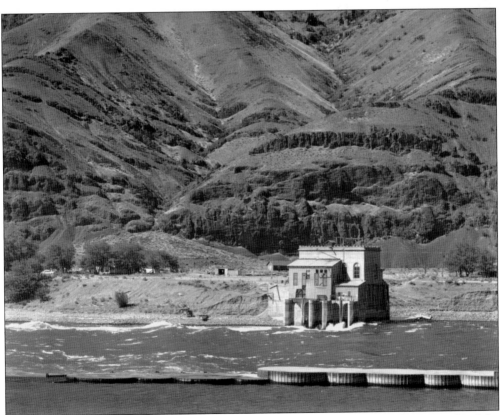

The first power-generating plant, seen here, was built at Priest Rapids on the west side of the Columbia River in 1908. It stood until the Grant County PUD tore it down while building the Priest Rapids Dam. The plant produced 2,500 kilowatts of power, and there were 50 to 75 customers in the area at the time. The plant was also intended to pump water for White Bluffs residents on the Benton County side of the river. (Courtesy of JoAnn Pearson.)

As early as 1918, businessmen campaigned for a dam in the Grand Coulee formation between Grant and Douglas Counties. Due to disagreement over the dam's location and who would finance and build it, dam construction was delayed for the next 14 years. James O'Sullivan, an Ephrata attorney who opened a law office in 1909 and bought land, was the first to put forth the idea that sale of electricity could pay for the dam's construction. Promoting Grand Coulee Dam construction became his life's work. (Courtesy of Grant County Historical Museum.)

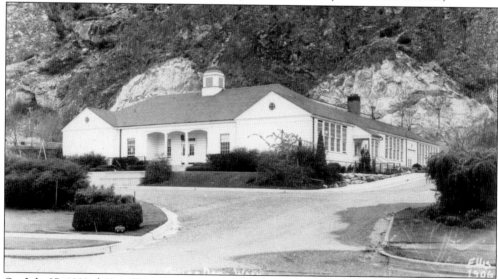

On July 27, 1933, $63 million was appropriated for the dam. The U.S. Bureau of Reclamation, who oversaw the project, appointed Frank Banks as chief construction engineer, and he hired 30 engineers to study the site. In 1934, the bureau leased land to build "Engineer's Town," which initially had 50 houses. In 1935, 25 more houses and this school were built. The bureau temporarily used the school until an administration building was completed. (Courtesy of Elizabeth Gibson.)

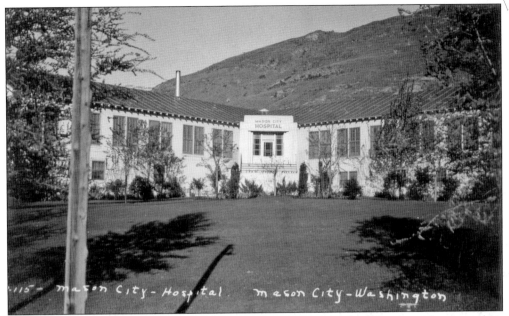

During 1935, Mason City was erected on the Okanogan County side of the river to house workers building the dam. The town was named for Silas Mason, chairman of the MWAK Company, the primary contractor for dam construction. This 33-bed hospital was built at the city and was the nearest facility for anyone who was injured at the dam site. Silas Mason later suffered a heart attack and died at this hospital. (Courtesy of Elizabeth Gibson.)

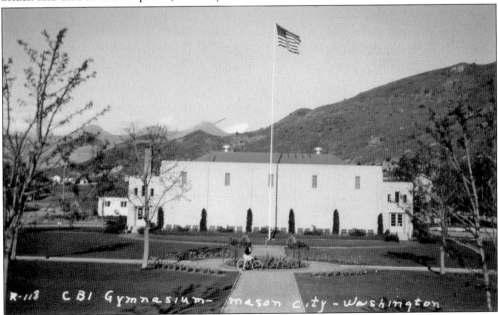

The White Pine Sash Company of Spokane initially built 360 homes at Mason City, as well as dorms, a cookhouse, and other structures. Later Consolidated Builders Inc. added more structures, including this new gymnasium attached to the high school. The gym was the site of sporting events in which residents of Mason City and Grand Coulee competed against each other. (Courtesy of Elizabeth Gibson.)

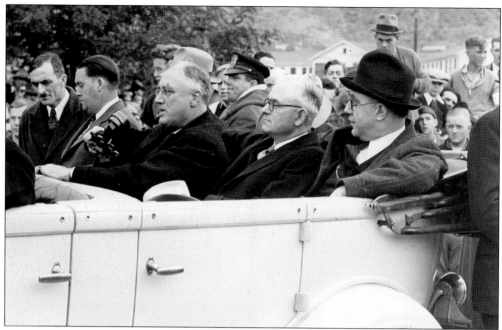

In 1937, Pres. Franklin D. Roosevelt visited the dam site. In August of that year, Roosevelt signed a bill creating the Bonneville Power Administration to control sale and distribution of electricity. Also that year, Congress passed a bill that awarded $13 million for dam construction. From that point on, federal appropriations were easily obtained, particularly after World War II began and the United States began assisting with the production of war materiel. (Courtesy of Mick Qualls.)

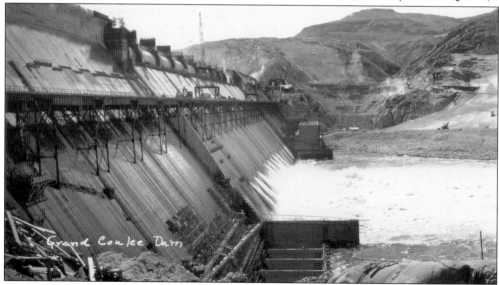

Initially Grand Coulee was designed as a low dam. But in 1935, federal funding control returned to Congress, from the Works Progress Administration. At that time, the Roosevelt Administration decided to build the high dam instead. Consolidated Builders, Inc., led by Henry Kaiser, won the contract for the second phase of dam. In this photograph, dam construction is well under way, with one powerhouse complete on the Grant County side. (Courtesy of Glen and Valerie Thiesfeld.)

Early in 1934, the U.S. Bureau of Reclamation built a highway from the dam site to Coulee City, the nearest supply area. The future Highway 155 was known as the Speedball Highway. Just south of Coulee City, a secondary road led to one of the most amazing natural phenomena—Dry Falls. After construction began, tourists came to see the dam and other scenery in the area. As early as 1939, a viewpoint existed at Dry Falls. (Courtesy of Elizabeth Gibson.)

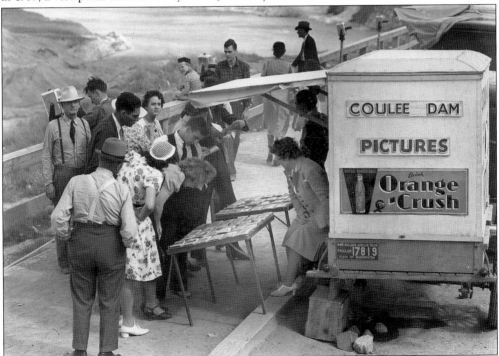

This viewpoint overlooked damn construction with coin-operated telescopes. Vendors all set up snack stands and souvenir shacks to take advantage of the tourists trade. (Courtesy of Moses Lake Museum and Art Center.)

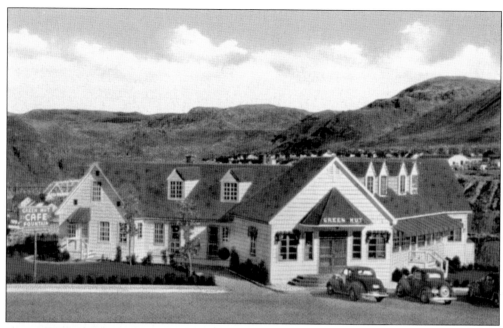

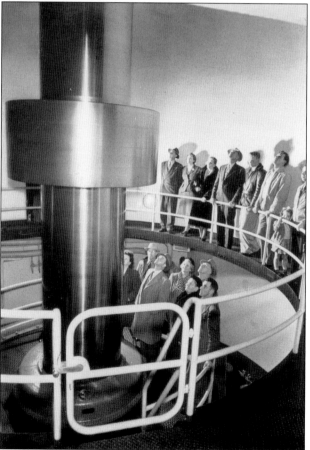

The Green Hut Café was a favorite restaurant for workers building the Grand Coulee Dam when it opened in 1938. The cafe was owned and operated by C. D. Newland. Chef McKinley Sayles worked there for 55 years. Diners could view the spillway of the dam from the restaurant. This landmark burned down on September 11, 1964. (Courtesy of Elizabeth Gibson.)

Visitors to Grand Coulee Dam inspect a generator drive shaft within the dam. This 200-ton drive shaft is 44 inches in diameter and about 75 feet long. It transfers power from a 160,000-horsepower turbine in the base of the powerhouse to a 120,000-kilowatt generator above the dam. This photograph was taken in 1944 after the dam's completion. (Courtesy of Elizabeth Gibson.)

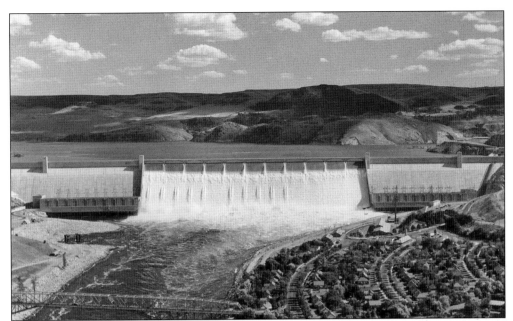

The dam was completed in 1941. The dam is 550 feet tall, 500 feet wide at the base, 30 feet wide at the crest, and 5,223 feet long. Eighteen generators produced 108,000 kilowatts each. The dam's construction completed the first phase of the Columbia Basin Irrigation Project and was used for power production during World War II. It would be several more years before canals, levees, and reservoirs carried water to Grant County. (Courtesy of Moses Lake Museum and Art Center.)

Engineer's Town stood at the base of the dam. Mason City sat on the north bank. The towns of Grand Coulee, Coulee Center, and Coulee Heights sprang up around Engineer's Town, eventually consolidating in October 1935. Mason City and Engineer's Town consolidated into Coulee Dam in 1942, and the streets in Coulee Dam followed the contour of the hillside. The sameness of the structures is typical of government-built homes. (Courtesy of Glen and Valerie Thiesfeld.)

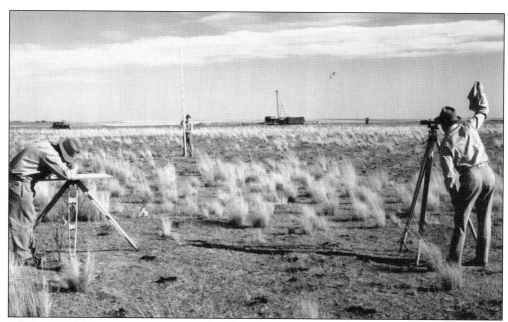

While work on the irrigation system continued, the U.S. Bureau of Reclamation opened 80-acre Predevelopment Farm No. 1 about two miles east of Moses Lake. These engineers studied the topography for land leveling and design of the irrigation system in 1946. Pictured are, from left to right, M. W. Hoisveen, B. W. Doran, and H. A. Sandwick, agriculture engineers from the U.S. Bureau of Reclamation. (Courtesy of Moses Lake Museum and Art Center.)

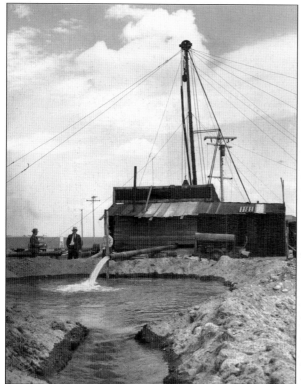

This is a testing well on the Moses Lake Predevelopment Farm in May 1947. During the 60-hour test, the well produced 1,050 gallons per minute. The men in the photograph are W. W. Johnston, project development supervisor; J. E. Toevs, chief land development; and Paul Bickford, civil engineer, community development. They are taking a sample of water for chemical analysis. (Courtesy of Moses Lake Museum and Art Center.)

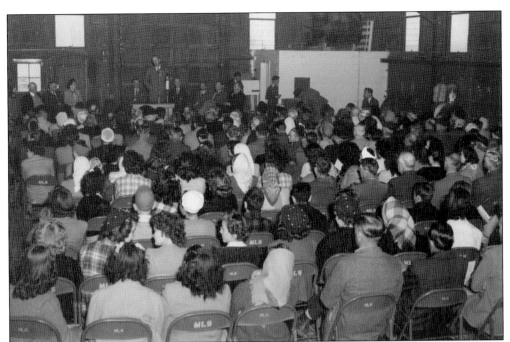

Dedication day at the Development Farm near Moses Lake was held on October 7, 1947. The ceremonies were held inside the huge machine shed during the afternoon and were attended by a large and attentive audience. Speaking is Congressman Hal Holmes of Ellensburg. (Courtesy of Moses Lake Museum and Art Center.)

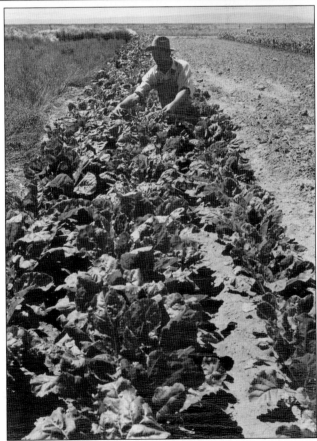

On part of the Moses Lake Development Farm, three rows of sugar beets were grown in 1948. From plots such as this, the adaptability of a crop to the particular soil and climate were studied. Sugar beets grew very well in this area, leading to the planting of several hundred acres in sugar beets and the erecting of a sugar refining factory. (Courtesy of Moses Lake Museum and Art Center.)

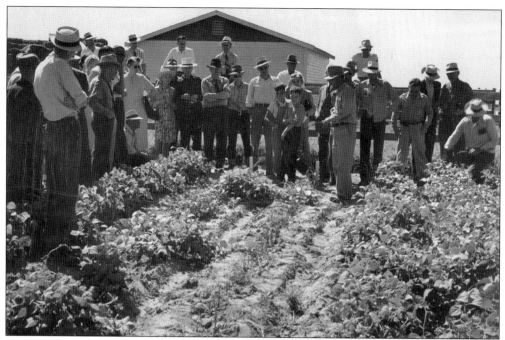

Visitors at the Moses Lake Development Farm observe several varieties of beans in the adaptability plots while a member of the state experiment station explains the work. Several nonresistant varieties are seen at the right and left. This experiment was also conducted in 1948. (Courtesy of Moses Lake Museum and Art Center.)

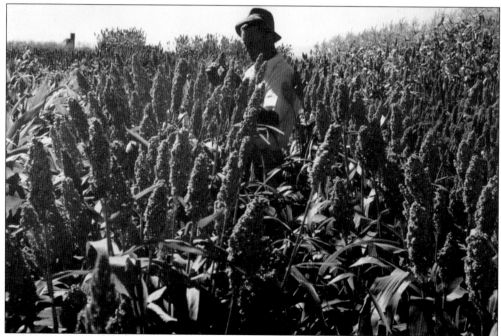

Sorghum varieties were also grown on the Moses Lake Development Farm in 1948. Growers hoped to show to what extent this crop could be grown in the Columbia Basin. Sorghums are grown as livestock feed either as dry grain or silage. (Courtesy of Moses Lake Museum and Art Center.)

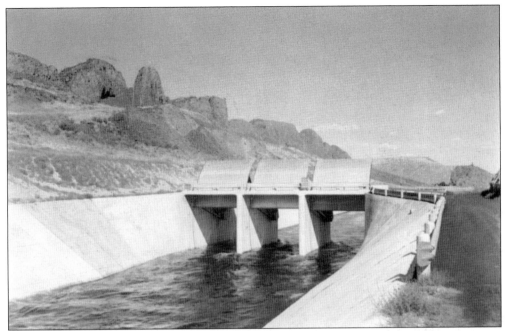

This irrigation canal carries water from the pumping plant at Grand Coulee Dam to the storage reservoir in the upper Grand Coulee. At the time, the canal was the world's largest at 50 feet wide at the bottom, 125 feet wide at the top, and 25 feet deep. It also has control gates to aid in repairs needed to the canal. (Courtesy of Elizabeth Gibson.)

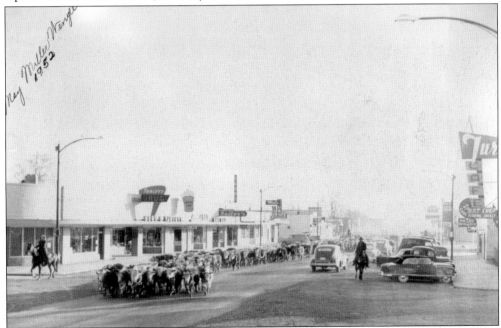

In 1952, May Miller (Wenger) drove the last herd of cows up Broadway Avenue in Moses Lake. Cowboys drove the cows from the Miller ranch to a government range near O'Sullivan Dam. Turk's restaurant, pictured on the right, is still in operation today. (Courtesy of Moses Lake Museum and Art Center.)

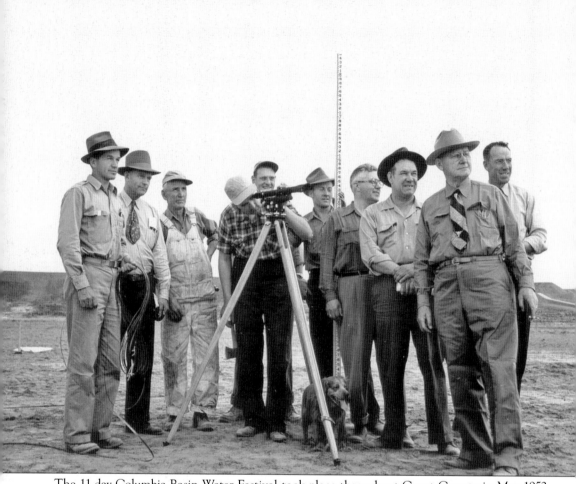

The 11-day Columbia Basin Water Festival took place throughout Grant County in May 1952 to celebrate the arrival of irrigation water from the Columbia Basin Irrigation Project. As part of the celebration, volunteers built a "Farm-in-a-Day." Pictured are the survey crews from left to right: Hazen Sandwick, Bureau of Reclamation; Cal Causey, American Federation of Labor; F. A. D'Shaw, carpenter; Charles Bennett, Moses Lake City Streets superintendent (at transit); Jack Umbewust, Bureau of Reclamation; James Pippins, City Street Department; George Olsen; Jim Wilson, Moses Lake plumber; William C. Bell, managing director of Western Retail Lumbermen's Association; and Ed Tull, Moses Lake manager of the Grant County PUD. (Courtesy of Moses Lake Museum and Art Center.)

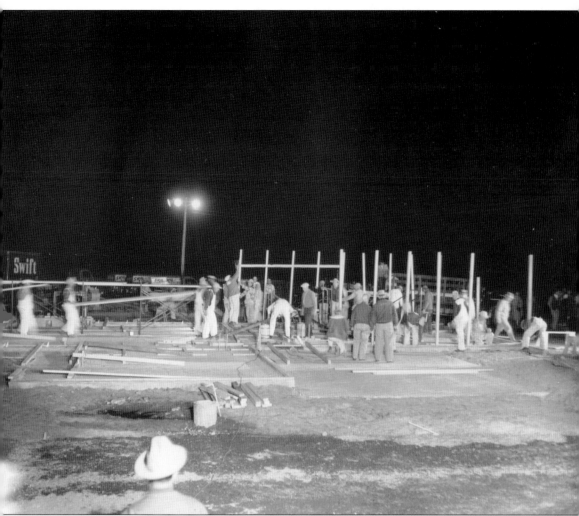

The farm built for the Farm-in-a-Day program was located near Moses Lake. The winner was selected by random drawing of war veterans. Donald Dunn, a Yakima farm-implement salesman won the $75,000 farm. The cement floor had been prepared prior construction. Work began at midnight on May 29, and although a brisk wind came up and workers were cold and dusty, they continued to work all night long. About 4 a.m. the wind calmed down so workers could begin construction of the farm buildings. By morning, sprinklers were watering the field. Electricity was turned on that afternoon. (Courtesy of Moses Lake Museum and Art Center.)

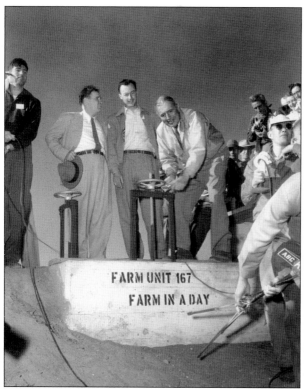

Twenty-four hours after work commenced, the 120-acre farm was complete. The crop acreage was 80 acres and some acreage would be used for raising cattle. Donald Dunn stands in the middle as the first irrigation water is pumped to the farm. The event received national coverage and was later described in *National Geographic* magazine. (Courtesy of Moses Lake Museum and Art Center.)

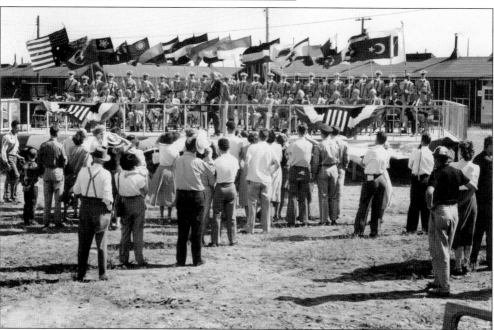

Commissioner Michael W. Straus of the Bureau of Reclamation speaks at the All-Nations Day Flag Ceremony at the opening of the Little World's Fair in Ephrata on May 28, 1952. The Little World's Fair was part of the Columbia Basin Water Festival. Honored guests on the platform included leaders in reclamation from 22 nations. (Courtesy of Moses Lake Museum and Art Center.)

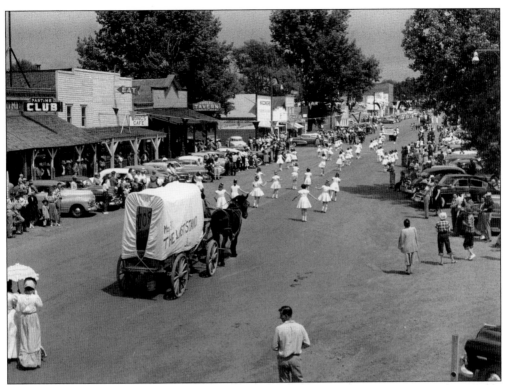

Coulee City held a pioneer parade and rodeo on May 31, 1952, as part of the Columbia Basin Water Festival. Coulee City was one of nine cities that participated in the Columbia Basin Irrigation Project. (Courtesy of Moses Lake Museum and Art Center.)

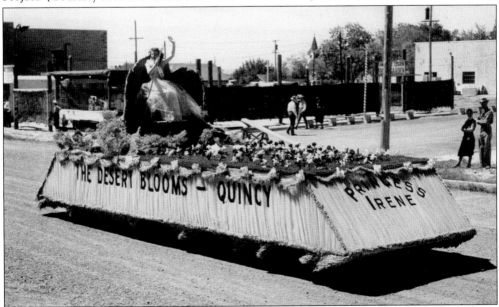

Princess Irene Snyder of Quincy rides in the chamber of commerce–sponsored float at the Quincy Day Parade on May 26, 1952. The float won a theme award at the Spokane Lilac Festival on May 17, 1952. (Courtesy of Moses Lake Museum and Art Center.)

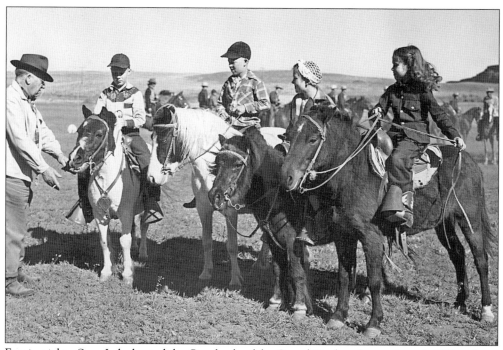

For six nights, Soap Lake hosted the Cavalcade of the Grand Coulee. Approximately 700 students performed, including these young riders from Coulee City. Phil Whiting, at left, interviews the riders. (Courtesy of Moses Lake Museum and Art Center.)

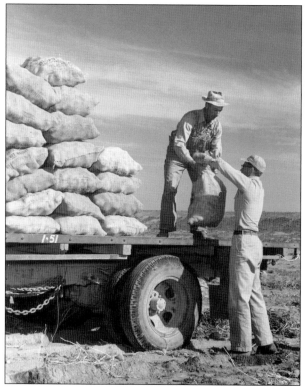

Everyone was curious how Donald Dunn fared on his Farm-in-a-Day. Here Dunn handles a sack of potatoes tossed up to him by his brother Max. Potatoes grew well because of the climate, good soil, and long growing season. However, Washington potatoes were not yet accepted on the market as they are today, and Dunn sold his farm after just a few years. (Courtesy of Moses Lake Museum and Art Center.)

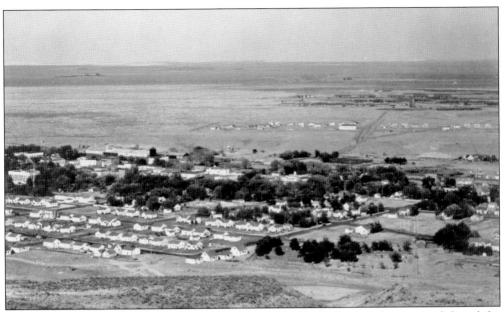

This 1950s aerial view of Ephrata is looking west to east, with the courthouse near left and the airport in the distance. The city grew quickly after construction of Grand Coulee Dam, and the Columbia Basin Irrigation Project also spurred more growth. The U.S. Bureau of Reclamation established a regional office in Ephrata. So did Grant County PUD, which distributed electricity throughout the county. (Courtesy of Elizabeth Gibson.)

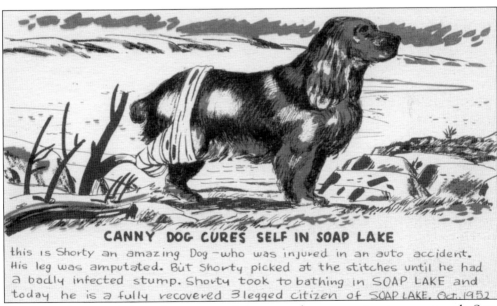

CANNY DOG CURES SELF IN SOAP LAKE
this is Shorty an amazing Dog —who was injured in an auto accident. His leg was amputated. But Shorty picked at the stitches until he had a badly infected stump. Shorty took to bathing in SOAP LAKE and today he is a fully recovered 3 legged citizen of SOAP LAKE. Oct. 1952

Once water began to irrigate the county, existing towns began experiencing new growth. Soap Lake advertisers tapped on old resources to attract visitors to this area. This postcard from Soap Lake is a demonstration of how much the citizens believed in the healing power of their lake. (Courtesy of Elizabeth Gibson.)

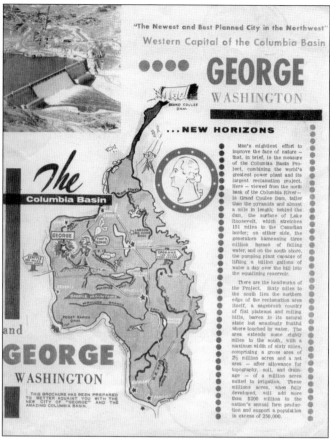

Like many other communities, George printed advertising brochures to entice visitors and hopefully lure permanent residents to the area. Brochures such as this emphasized the climate, good growing conditions for farming, and the good people. (Courtesy of Rick Bowles.)

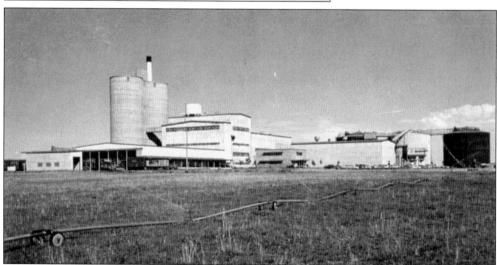

The U&I Sugar Company of Salt Lake City opened a sugar refinery in 1953. The plant occupied 1,600 acres and would employee 50 permanent and 250 seasonal workers. When it first opened, it could process 2,000 tons of sugar beets in a 24-hour period. By the time the plant closed in 1978, it was processing 11,500 tons per day. The higher cost of beet sugar over cane sugar caused its closing. (Courtesy of Elizabeth Gibson.)

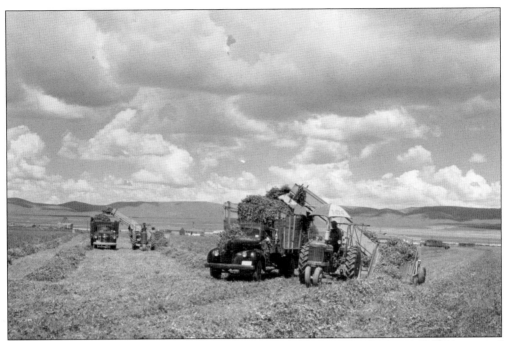

These loaders pick up windrowed pea vines in a pea field near Winchester in 1952. As part of the area irrigated by the Columbia Basin Irrigation Project, both seed and fresh peas were grown in this area. Seed peas average 2,600 to 3,000 pounds per acre; fresh peas average 4,000 pounds per acre. (Courtesy of Quincy Valley Historical Society.)

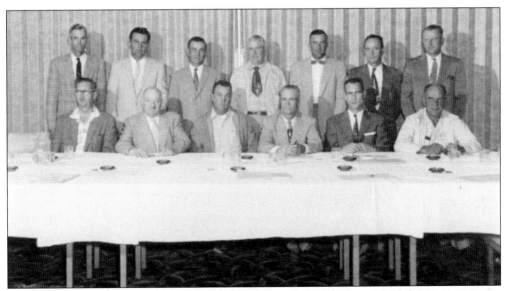

The Washington State Potato Commission formed in 1956. The goal of the commission is to enhance trade opportunities, to advance environmentally sound growing practices, and to represent growers' interests. The original commissioners are as follows: Percy Kelly, Ed McKay, Percy Driggs, John Rambosak, Walter Bynum, E. E. Benz, Walt LePage, Newell Anderson, Dave Clark, Howard Hales, Norm Nelson, Gerry Dodge, and Fred Ramsey, manager. (Courtesy of Washington State Potato Commission.)

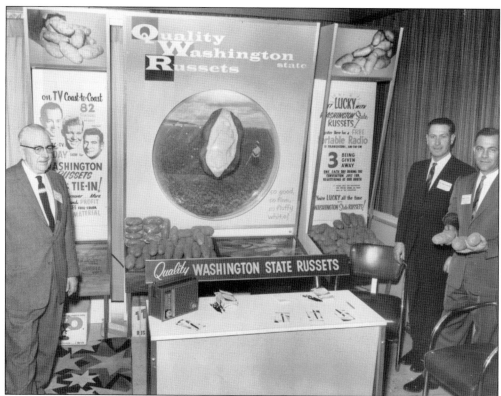

The Washington State Potato Commission vigorously promoted the nutritional advantages and production of Washington potatoes. Displays such as the one shown were staged at fairs and trade shows. Columbia Basin potato fields can yield as much as 60,000 pounds of potatoes per acre, the highest yield in the country. The russet potato is the most widely used and is packed in 50-pound boxes in 10 different sizes and two different grades. (Courtesy of Washington State Potato Commission.)

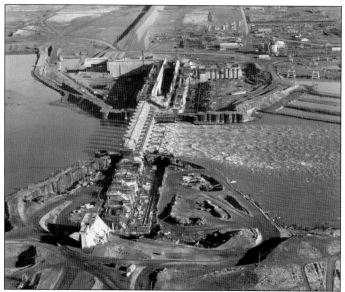

Washington Water Power of Spokane brought the first electricity to the area, but residents wanted their own source. Grant County PUD District No. 2 formed in 1938. But it wasn't until the 1948 flood that Congress finally authorized a dam at Priest Rapids. Construction began on Priest Rapids Dam in 1956, by Merritt, Chapman, and Scott, the lead contractor. This view shows the progress of dam construction in early 1959. (Courtesy of JoAnn Pearson.)

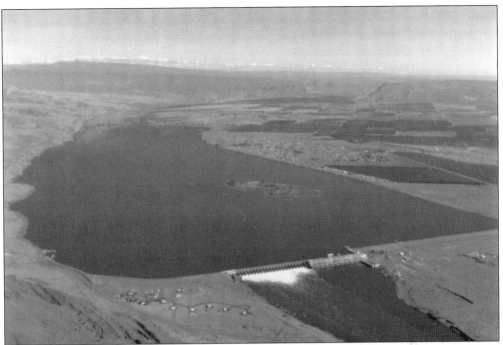

Priest Rapids Dam was completed in 1961 at a cost of $166 million. All 10 generators were operating by July 1961, several months ahead of schedule. The dam produces 955,600 kilowatts of electricity per hour. During dam construction, the nearby settlement of Mattawa boomed. The dam is operated by the Grant County Public Utility District. (Courtesy of Grant County PUD.)

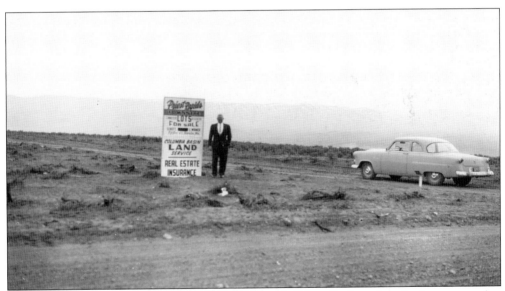

Mattawa was founded in 1909 when E. and Eva Campbell from Spokane bought the property, but the area was not developed until the Priest Rapids Development Company drilled a well, brought water to town, and started selling lots, which were first sold around 1955 by Morris Schott and F. C. Freeman. If it weren't for the impending dam construction, this settlement may never have happened. This sign stood where Mattawa was first developed. (Courtesy of John Ball.)

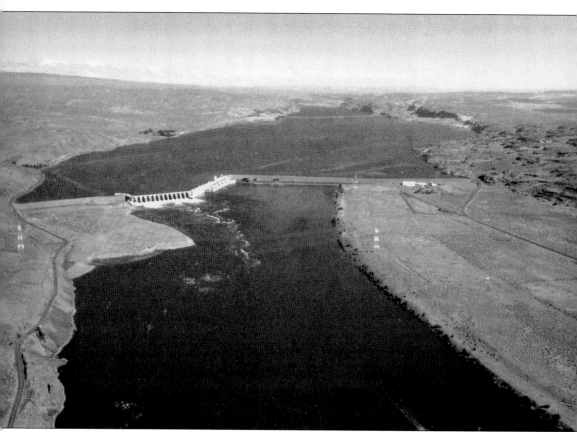

Bids on Wanapum Dam were solicited in 1959. The Morrison-Knutsen Company led construction and completed the dam 18 months ahead of schedule. Construction began in 1959. The first power was generated in September 1963. By January 1964, all 10 generators were producing electricity. An official dedication ceremony was held on June 4, 1966. The dam produces 1,038,000 kilowatts of electricity per hour. The Wanapum Dams is operated by the Grant County PUD. Grant County uses 36.5 percent of the power produced and sells the rest to nine other northwest public and private utilities. (Courtesy of Grant County PUD.)

Nine

MODERN TIMES

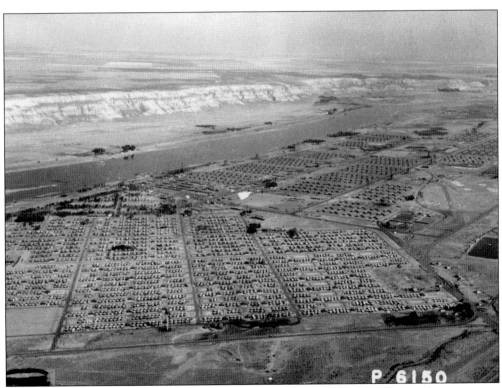

In 1943, the federal government condemned the northern part of Benton County for a top secret government project. This huge construction camp housed the workers who would manufacture the plutonium for the atomic bomb at the Hanford Nuclear Reservation. Across the Columbia River in Grant County, the federal government also created a buffer zone of several miles, from which ranchers and homesteaders were required to leave. Ferry operators also had to leave. (Courtesy of Columbia River Exhibition of History, Science, and Technology.)

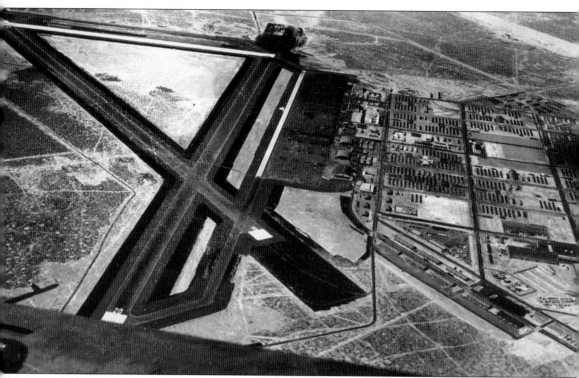

In 1941, the county leased land southwest of Moses Lake to be used as a bombing range, and soldiers moved to Ephrata to build it. Bomber crews from McChord Air Force Base in Tacoma began using the Ephrata Airport as their base. Runway No. 1 was 150 by 5,000 feet. After the bombing of Pearl Harbor, the area became an official air base on June 19, 1942. Ultimately the base, pictured here from the air around 1943, became the home of 307th Bomb Group. (Courtesy of Ephrata Airport Interpretive Center.)

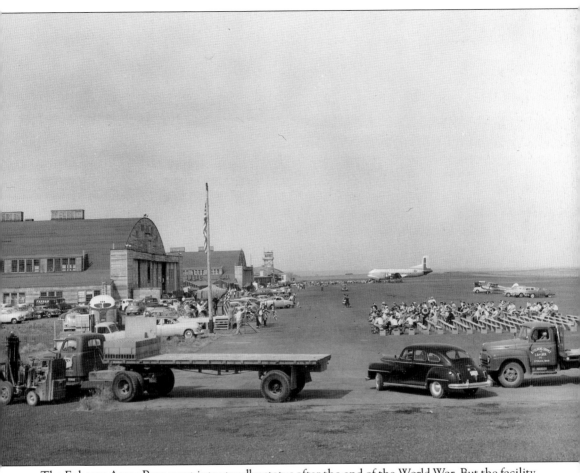

The Ephrata Army Base went into standby status after the end of the World War. But the facility was still in use by the U.S. Bureau of Reclamation and others over the next few years. When the basin celebrated the Columbia Basin Water Festival in May 1952, the old base held an open house. Visitors gather in the foreground for the Elks flag ceremony. In the background is a C-124 Globemaster plane flown from Larson Air Force Base. Tours were offered of these huge aircraft, which were 130 feet long and 48 feet tall, and could carry 200 troops with 5 crew. (Courtesy of Moses Lake Museum and Art Center.)

Moses Lake Army Air Base was used from 1942 to 1945. During that time, this military train supplied the base with goods from local businesses as well as military sources. The base was placed on standby in 1945, but it was reactivated in 1948 as part of the Air Defense Command. (Courtesy of Schiffner Military Museum.)

Though located in a desert, residents in the area still experience cold winters. Due to its proximity to the Columbia River and Umtanum Ridge on the west bank, winds and snow can bring challenges to residents and travelers alike. However, winter snows can also bring beautiful scenery, such as this view of the river. (Courtesy of Bud Clerf.)

In 1950, Moses Lake Army Air Base was renamed Larson Air Force Base after Maj. Donald A. Larson, a World War II flying ace from Yakima, was killed in action over Germany in 1944. The base remained open to protect the nearby Hanford Nuclear Reservation and Grand Coulee Dam. From left to right are pilots Col. Bradley W. Prior, Col. Clyde W. Owen, Col. David A. Tate, Col. John E. Murray, and Col. Harold G. Cowan. (Courtesy of Schiffner Military Museum.)

On April 1, 1952, the Tactical Air Command took over Larson Air Force Base. At that time, the 62nd Troop Carrier Wing moved to Larson from McChord Air Force Base. Pictured is Brig. Gen. H. W. Bowan, commander of the base. During his tenure, the division tested B-52 bombers. (Courtesy of Schiffner Military Museum.)

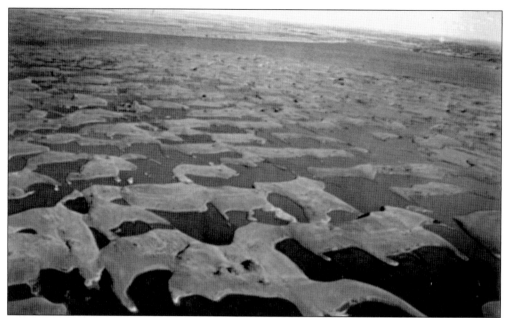

The Potholes Reservoir collects water behind the O'Sullivan Dam, completed in 1962. The dam contains 8,753,000 cubic yards of rock and earth piled 200 feet high, 19,000 feet long, and 30 feet wide. Average water storage is 511,700 acre feet. A canal drains the reservoir to the south, where it takes water to Grant County, east Adams County, and Franklin County. The drainage created these dunes in pools at the north end of the reservoir. (Courtesy of Elizabeth Gibson.)

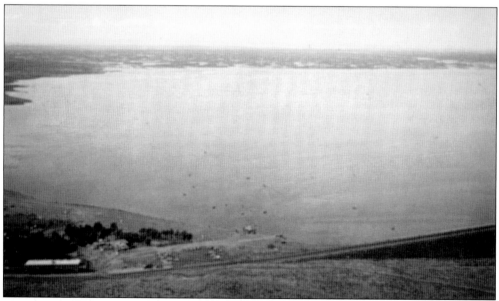

The Mar-Don Resort sits at the west end of O'Sullivan Dam. The resort is popular for camping, fishing, and hunting at the Potholes Reservoir. Visitors also enjoy the lakes of the Columbia Wildlife Refuge just south of the dam. These lakes have been created by seepage and wastewater escaping from the canals and irrigated areas of the Columbia Basin Irrigation Project. The Meseberg family has operated the resort for more than 30 years. (Courtesy of Elizabeth Gibson.)

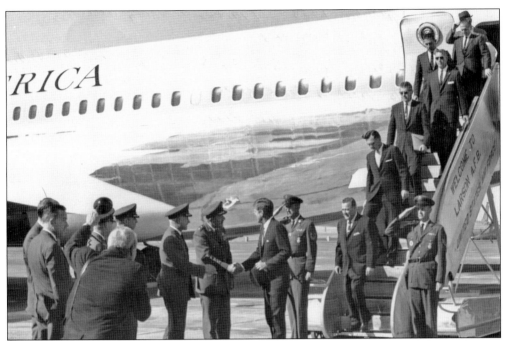

On, September 23, 1963, Pres. John F. Kennedy arrived for the ground breaking ceremony of the 100-N Reactor at the nearby Hanford Nuclear Reservation. Larson Air Force Base was the closest airport that could accommodate Air Force One. Here President Kennedy shakes hands with General Kingsbury, commander of the 18th Air Division. Col. David A. Tate stands next to Kingsbury, and state senator Warren Magnuson is seen coming down the ramp. (Courtesy of Schiffner Military Museum.)

In the early 1960s, the government built three Titan missile bases in and around Grant County, near Royal Slope, Warden, and Batum in Adams County. Some felt these Titan missile sites were necessary to protect the nearby Hanford Nuclear Reservation and Grand Coulee Dam. The three missile sites were one of 14 squadrons in the United States, although the missiles were never fired or tested. They were removed by July 1965. (Courtesy of Schiffner Military Museum.)

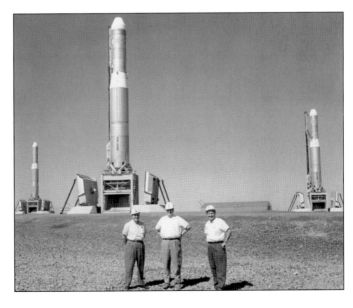

On November 19, 1965, the secretary of defense announced that Larson Air Force Base would be closed by June 1966. Some buildings were used to temporarily house the new Big Bend Community College. The runway and other airport structures were saved and became part of Grant County International Airport, which was dedicated on October 8, 1966. Bruce W. Johnson, public affairs director for the Boeing Company, was the master of ceremonies. (Courtesy of Schiffner Military Museum.)

Big Bend Community College opened in 1962 in Moses Lake, and Dr. Alfred M. Phillips was the first president of the college. At first, the college did not have its own campus, so the high school was used at night. The college had 17 teachers and 86 students that first year and fielded a basketball team and a wrestling team. Dr. Phillips remained president for the first two years. (Courtesy of Big Bend Community College.)

These men represented the 1962 school board at Big Bend Community College. Pictured are, from left to right, (first row) Richard D. Bennion and Dr. Robert Goodwin; (second row) Dr. Anson F. Hughes, Dr. Darrell H. Larson, and William F. Duncan. These men were instrumental in ensuring the college was built and took many trips to Olympia to make it happen. (Courtesy of Big Bend Community College.)

The most recognizable feature of the college is this structure known as "the mall," which covers the area between the science and administration buildings. Construction of the mall began in 1963. Each of the overhead concrete slabs weighs nine tons. Construction was delayed for a short time because of cold weather. (Courtesy of Big Bend Community College.)

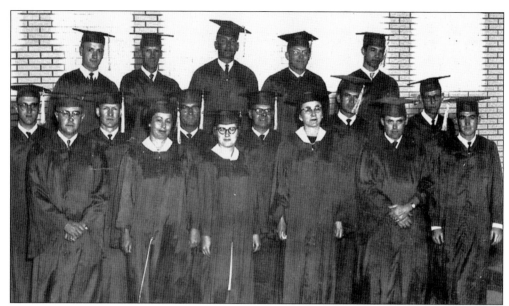

The first class graduated from Big Bend Community College in 1963. Seventeen of the first 20 graduates are pictured. The class included Robert Edward Berg, Robert Dale Bowers, Janet Jean Cox, Christopher C. Davis Jr., Donald L. Dewey, Robert Blair Fisher, Charles L. Gray, Benjamin D. Herbert, Helen J. Herold, James R Knapton, George L. Lang, Mary Evelyn Lucke, Diane Meyer, David T. Moody, Arthur G. Morrell, Deland Romine, Raymond Rossignol, John Gerald Sowicki, Josef Spies, and Warren L. L. Wendland. (Courtesy of Big Bend Community College.)

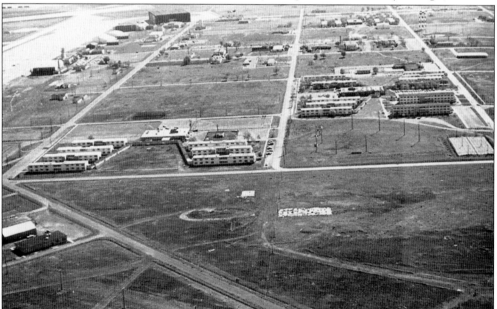

On July 9, 1969, the Big Bend Community College Board of Trustees voted to abandon the new south campus and relocate the college to the abandoned Larson Air Force Base by 1971. This photograph shows the buildings at the base that the college would soon occupy. Today only a few of these buildings are still in use, though the college still occupies the property. (Courtesy of Big Bend Community College.)

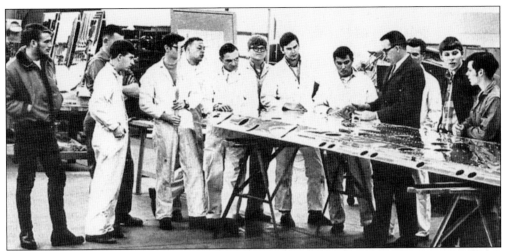

Since the early days, the college has linked itself to careers in aviation. Here a 1969 class in aircraft mechanics inspects the frame of an airplane. Pictured from left to right are Allen Francisco, Kelcey Gaylan, Lorne Banham, Dan Patten, Perry Freeborn, Tom Wisniewski, Ron Piercy, Dana Rudd, Tibureio Herrera, Russ Biggers, Orland Larson, Gary Burgess, and Dave Geaudrea. (Courtesy of Big Bend Community College.)

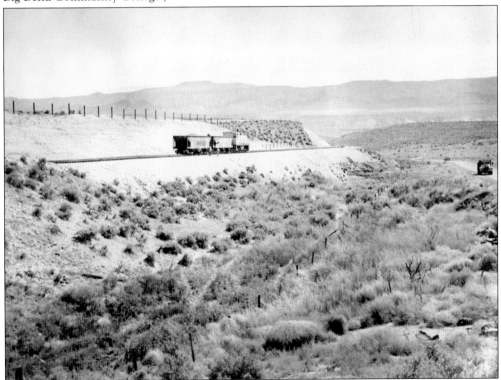

This photograph of the Chicago, Milwaukee, and St. Paul Railroad was taken in the mid-1960s. This spur of the railroad contained 6.4 miles of tracks from the main line near Smyrna to the edge of Royal City to serve 90,000 acres in the Royal Slope area. The line followed Red Rock Canyon on sharp curves at 2.5 percent grade. The locomotive is hauling cars near the newly completed Hiawatha Industrial District of the railroad near Royal City. (Courtesy of *South County Sun*.)

As usual, George residents made their cherry pie to celebrate Independence Day in 1964. Sen. Henry M. Jackson spoke at the celebration held at the City Park at City Center, and then Charlie Brown spoke. The town had a population of 300 by this time. (Courtesy of Virginia Sheldon.)

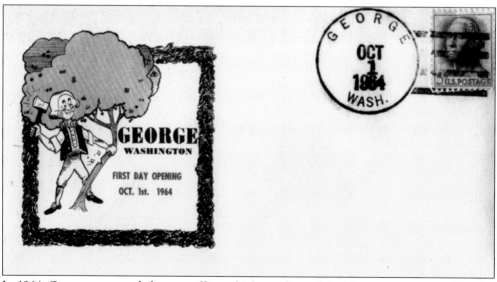

In 1964, George was awarded a post office, which was located inside a grocery operated by the Browns. Mrs. Brown was the first postmaster. This first day cover commemorates the opening of the post office at George. (Courtesy of Virginia Sheldon.)

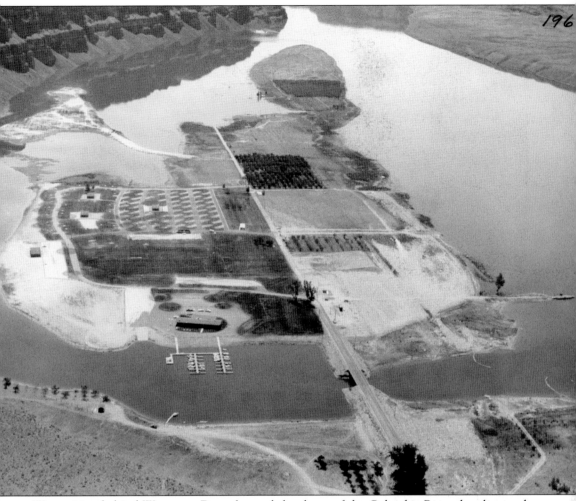

Water rising behind Wanapum Dam changed the shape of the Columbia River shoreline and its islands. On the Grant County shoreline, where it meets with Kittitas and Douglas Counties, the Crescent Bar Recreation Area was established on a Columbia River island. This photograph was taken in 1965, when boating and picnic areas were being developed. Camping, tennis, and golf are now available at the Crescent Bar Resort, which is very popular in the summer. Travelers can also rent condominiums and enjoy a variety of water sports. (Courtesy of Quincy Valley Historical Society.)

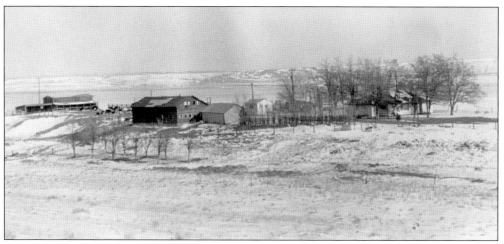

Pictured is the Schiffner farm in west Moses Lake in the 1960s. Frank Strode developed the farm, and the house was built in 1951. George and Margaret Schiffner bought the farm in 1961. George Schiffner died in 1999, but Margaret Schiffner continued to live there until 2005, at which time she built a new home to display her antiques and collections. (Courtesy of Margaret Schiffner.)

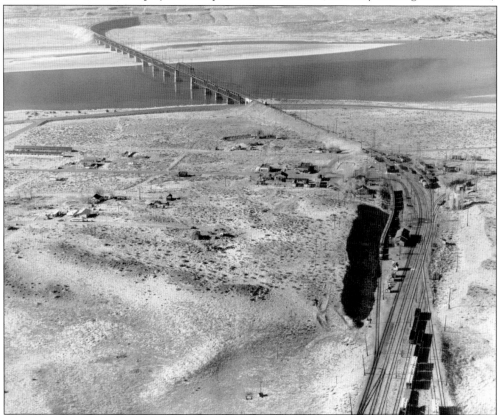

This view of Beverly was taken in the early 1960s. The railway bridge across the Columbia can be seen in the background. Just visible at the waterline is the highway (now State Highway 243). Other than a few businesses clustered around the railway depot, there were few other buildings. Beverly never did grow into a boomtown as its promoters projected. (Courtesy of JoAnne Pearson.)

This photograph of George and Margaret Schiffner was taken in 1971. Longtime residents of Moses Lake, the couple raised three children here. Over the course of more than 30 years, the Schiffners collected military and police memorabilia focusing on the local history. Their collection of photographs and documents from the Larson Air Force Base is one of the most extensive anywhere. (Courtesy of Margaret Schiffner.)

In the summer of 1971, Ephrata hosted a Sagebrush Olympics event. This certificate commemorated the event, which took place over the last weekend in June. The highlight of the weekend was a grand parade down Ephrata's Basin Street. There was also a dance, races for the kids, barbecue, historical program, and muzzle loader's shooting contest. (Courtesy of Elizabeth Gibson.)

Washington experienced one of the biggest disasters in its history when Mount St. Helens erupted on May 18, 1980. Towns in eastern Washington were in the path of the mountain's plume as wind carried ash around the world. Moses Lake was hit especially hard, with 4 to 6 inches of ash falling around the area. The mess took months to clean up. (Courtesy of Moses Lake Museum and Art Center.)

Desert Aire was also inundated by Mount St. Helens ash. A layer of ash on the car and sidewalk look like snow has just fallen. Here Dave Best begins cleaning up the mess by brushing off his car. This had to be done carefully because the ash was abrasive and could scratch the paint. (Courtesy of Velma Best.)

The Oregonian

ESTABLISHED 1850

1320 S.W. BROADWAY PORTLAND, OREGON 97201

January 15, 1980

Mr. George Schiffner
Moses Lake, Wn.

Dear Mr. Schiffner:

Why anyone would want to remember anything about Moses Lake
base is beyond me, as it was my first duty post after graduating
in the Class of 43-F at Marfa, Texas. The place was half-finished,
had no hanger...they had to put a canopy over the engines to do
a 25 or 50-hour inspection. We slept in tarpaper barracks; had
to run obstacle courses out in the sagebrush, with a smart-ass
corporal telling us brand new lieutenants what to do, and other
miseries. The only redeeming thing about the place was the
officers' club, which was completed and a fairly nice facility.
On Saturday nights, they'd bring in a bunch of girls from
Ephrata for some companionship on the dance floor.

For what it's worth, I've got a couple of letters I wrote to
my parants in Minnesota from Moses Lake in June, 1943, telling
them of my impressions of the place. You're welcome to them
if you want them.

Cordially,

Edward S. Niederkorn
Promotion Mgr.
THE OREGONIAN

To expand their collection, the Schniffers gathered information about Larson Air Force Base from all over the United States. Pictures here is one of many letters they received to their inquires for information. Judging by the letter, the serviceman didn't enjoy his stay at Larson Air Force Base. (Courtesy of Schiffner Military Museum.)

Earl and Ruby Holloway moved from Idaho to the Quincy area in 1953. Initially they planted hay and red Mexican beans. Both were active in the county and state farm bureaus in an effort to address agricultural problems. They also joined some farmers and businessmen to form Quincy Chemical Research to study other uses for potatoes. Here are Earl and Ruby in 1980 showing off their huge potatoes. (Courtesy of Bob Holloway.)

In addition to the Fourth of July, George residents went all-out to observe Washington's birthday in February each year. Here volunteers at the Bi-George Market serve a huge 3-foot-by-5-foot birthday cake. This cake, served in 1985, was laid out on a wooden door, which was used as a serving pan. Jeannine Bowles, daughter of the Browns, stands in the middle. (Courtesy of Virginia Sheldon.)

The Gherke Windmill Museum is located in Electric City, near Grand Coulee Dam. The display is located near the town on the north side of Highway 155. Emil Gherke built the windmills from items he found in dumps beginning in 1965. His wife, Vera, painted the windmills. The display was created around 1975. (Courtesy of Elizabeth Gibson.)

Grant County International Airport began as Moses Lake Army Air Base, which was later renamed Larson Air Force Base. After the decommissioning of the base, the grounds became the Grant County International Airport. The Boeing Company, Japan Airlines, the U.S. military, and other air carriers now use the airport for training pilots and testing jets. The main runway is 13,500 feet long and is a designated emergency landing area for the space shuttle. (Courtesy of Port of Moses Lake.)

Chem-Con Materials Corporation is a Japanese company that manufactures rolled electrolytic aluminum foil, which is used in electronic capacitors. Originally called U.S. KDK Corporation, the facility opened in 1995. It was the first manufacturing company to take advantage of the Foreign Free Trade Zone that has been established at the Port of Moses Lake. (Courtesy of Port of Moses Lake.)

Solar Grade Silicon, or SGS, maintains a manufacturing facility at Moses Lake. The company takes raw silicon (found in sand) and turns it into silane gas, which is used in the production of polycrystalline silicon used to make photovoltaic cells for solar panels. The parent company is Renewable Energy Corporation of Norway, and they have plans to expand the facility. (Courtesy of Port of Moses Lake.)

Inflation Systems, Inc., an affiliate of Takata Corporation, was originally called Takata Moses Lake, Inc. The company makes automotive safety devices, with headquarters in Japan. In 1991, Inflation Systems partnered with Rocket Research Company, a Redmond, Washington, unit of the Olin Aerospace Division to expand their operations at the Grant County International Airport. (Courtesy of Port of Moses Lake.)

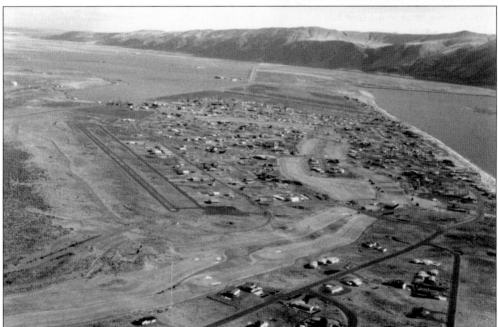

This recent photograph shows Desert Aire from the air. It has a small airport; the runways can be seen at center left. The grassy areas show the layout of its 18-hole golf course, and the residences are clustered around the golf course. Highway 243 neatly divides the desert from the green developed area of Desert Aire. This view looks approximately southwest, with the Columbia River to the west. (Courtesy of Bob Kibler.)

Ephrata resident Bob Holloway enjoys driving his powered parachute around Grant County and has participated in cross-country flights. Here he stays close to home as he soars over Soap Lake, approaching from the south. (Courtesy of Bob Holloway.)

Steamboat Rock, named for its massive shapes, rises from the north end of Banks Lake. This basalt formation once stood alone in the middle of the Grand Coulee, surrounded by native grasses and wildlife. Once water from the reservoir behind Grand Coulee Dam was pumped into the coulee beginning in 1951, the rock was surrounded by water. A small area has now been developed and is a popular camping, fishing, and hiking area. (Courtesy of Bob Holloway.)

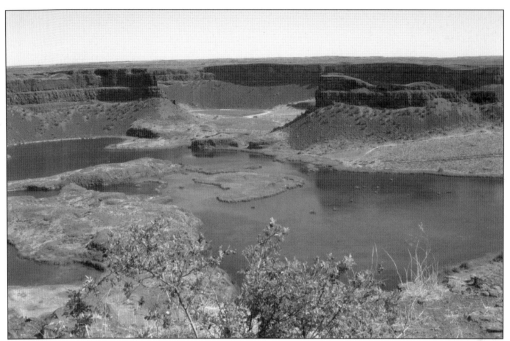

The basalt cliffs at Dry Falls are the remnants of ancient lava flows. Layers between the flows can be seen in their erosion patterns. Eons ago, the Columbia River flowed over these basalt cliffs. It is estimated that the distance around the rim and the depth of the channel is larger than Niagara Falls! Now the bottom of Lower Grand Coulee is filled only with small pools, seepage from the Columbia Basin Irrigation Project. (Courtesy of Bob Holloway.)

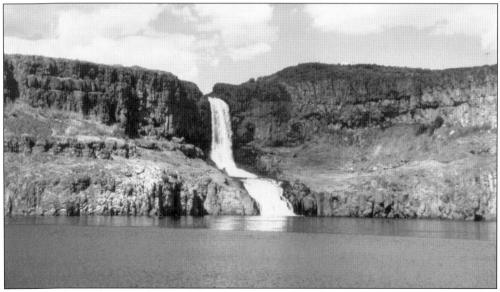

Summer Falls, in the central part of the state, are 165 feet tall. The falls are part of a state park created by the Columbia Basin Job Corpsmen from Larson Air Force Base in 1966. The corpsmen built a parking lot and a boat launch and drilled a well and installed a sprinkler system for the picnic area. The falls channel water from Banks Lake into Billy Clapp Lake in the central part of the county. (Courtesy of Elizabeth Gibson.)

ACROSS AMERICA, PEOPLE ARE DISCOVERING SOMETHING WONDERFUL. *THEIR HERITAGE.*

Arcadia Publishing is the leading local history publisher in the United States. With more than 3,000 titles in print and hundreds of new titles released every year, Arcadia has extensive specialized experience chronicling the history of communities and celebrating America's hidden stories, bringing to life the people, places, and events from the past. To discover the history of other communities across the nation, please visit:

www.arcadiapublishing.com

Customized search tools allow you to find regional history books about the town where you grew up, the cities where your friends and family live, the town where your parents met, or even that retirement spot you've been dreaming about.